POSTCARD HISTORY SERIES

Spring City and Royersford

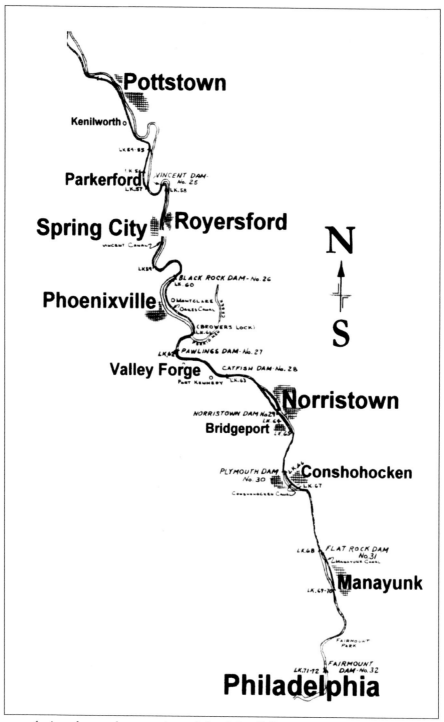

This map depicts the southern section of the Schuylkill Navigation Company system, from Pottstown south to the port of Philadelphia. The time period represented is the early 1820s.

POSTCARD HISTORY SERIES

Spring City and Royersford

William C. Brunner

ARCADIA
PUBLISHING

Published by Arcadia Publishing
Charleston, South Carolina

Printed in the United States of America

Library of Congress Catalog Card Number: 2003103451

For all general information contact Arcadia Publishing at:
Telephone 843-853-2070
Fax 843-853-0044
E-mail sales@arcadiapublishing.com
For customer service and orders:
Toll-Free 1-888-313-2665

Visit us on the Internet at www.arcadiapublishing.com

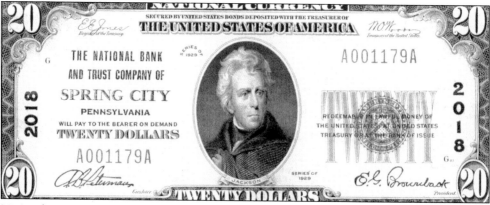

National currency notes were printed by the United States and issued through local banks. This $20 bill has the National Bank and Trust Company of Spring City printed on its face. The $10 bill is from the National Bank of Royersford. Both are from the 1929 series and are legal tender.

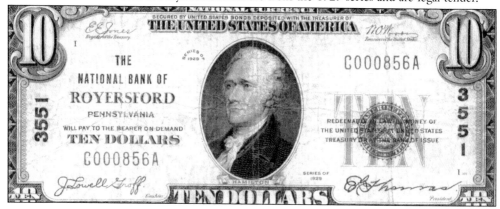

CONTENTS

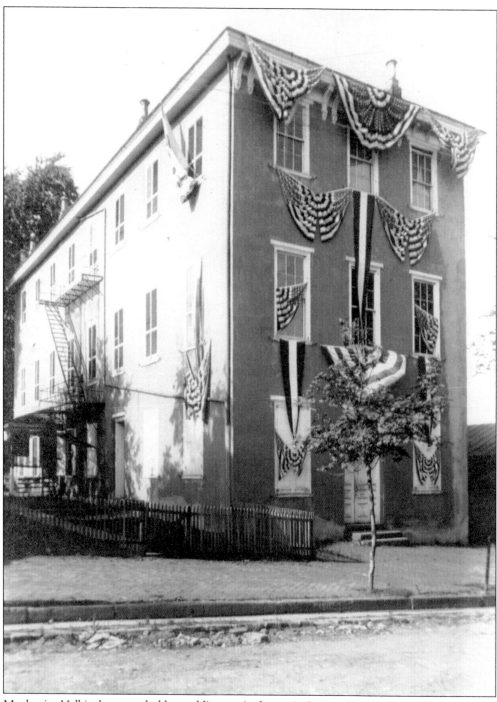

Mechanics Hall is the second oldest public meetinghouse in Spring City. Located at the bottom of Hall Street across from the firehouse, it is now known as the Tall Cedars Temple. This building was constructed in 1852 and was used by many organizations. Several churches, including the Lutheran and Reformed, held services there before their houses of worship were built.

INTRODUCTION

The first white man who lived in this area was a French Canadian fur trapper by the name of Pierre Bezallion. He lived in a cave along the banks of the Schuylkill River on land that is now located in the town of Spring City. Bezallion traded with members of the Lenni Lenape Indian tribe, the original inhabitants of this area, and used the cave for the storage of his furs. Although he died in 1742, there are still people today who search for his hidden cave. With the building of the Schuylkill Canal, it is probable that the old cave was buried forever.

Along the winding Schuylkill River, the Schuylkill Canal was opened in 1824. The Schuylkill Navigation Company was in operation by that time. From Pottsville to Philadelphia, the north-to-south route was open, and so was the path for industrial development in the small village of Springville. In 1839, the Philadelphia and Reading Railroad, whose tracks followed the riverbanks, was opened, and Royer's Ford became a railroad town. Just as the canal had caused growth across the river in Spring City, now Royersford was destined to grow. The following year saw the first bridge, a covered wooden structure, connect the two small towns. Industries sprung up on both sides of the river. A paper mill, stove works, glassworks, and (later) knitting mills were just a few of the various enterprises that flourished in these two towns. The people came, and with them came the houses, churches, schools, and of course local government. Springville was chartered in 1867, and in 1872 its name was officially changed to Spring City. In 1884, the Pennsylvania Railroad was opened from Reading to Philadelphia, with a station stop in Spring City. This obviously gave the Reading Railroad in Royersford some competition. Royersford was incorporated into a borough in 1879. In 1899, the Chester and Montgomery Traction Company began operation of a trolley that went from Spring City to Phoenixville. The trolley made many stops on its way, one being Bonnie Brae Amusement Park. As the name printed on the trolley company's stock certificates implied, it intended for trolley service to extend over to the Montgomery County side of the river, but all service ended in 1924, and this plan was never put into action. The twin cities remained separated by the river but forever linked by a bridge.

Over the years, the towns have endured their share of disasters. Fires, floods, and train wrecks come to mind. Situated on the banks of the Schuylkill River, most of First Avenue in Royersford and all of what is known as the lowlands in Spring City lie within the flood plain. Some of us may remember the flood of 1972, but that was only one of many local floods. The flood of 1850 washed away the first covered bridge that linked the two towns. In 1901, another great flood damaged local businesses, as did the flood of 1942. Fire destroyed the Yost gristmill as well as the second covered bridge in 1884. In 1856, the Spring City Foundry burned down. In 1891, the

Shantz and Keeley Stove works burned down, along with the Springville Hotel and most of the homes on Main Street between Hall and Chestnut Streets. A major train wreck on the Reading lines just above Royersford in 1914 was one of many that occurred over the years.

These towns shared not only sorrow but also joy. Celebrations were numerous. From the opening of the old iron bridge to the World War I victory parade, from the ending of World War II to the centennial celebrations, the twin cities have shared the good times. The jointure of the schools from both towns occurred in 1955, with the formation of the Spring-Ford Area School District. The two towns that shared a rich industrial history now had one more thing in common. Their children shall walk together hand in hand.

One

FROM THE SCHUYLKILL

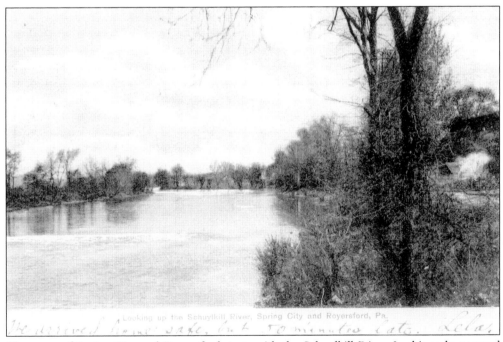

The story of Spring City and Royersford starts with the Schuylkill River. In this early postcard view looking up the Schuylkill, the area where early travelers crossed the river is apparent. The whitewater area in the picture was where the shallow part of the river allowed passage. The Royers brothers, who lived in Spring City, operated a ford. The name "Royersford" was derived from "Royer's Ford" and was adopted in recognition of Benjamin and David Royer.

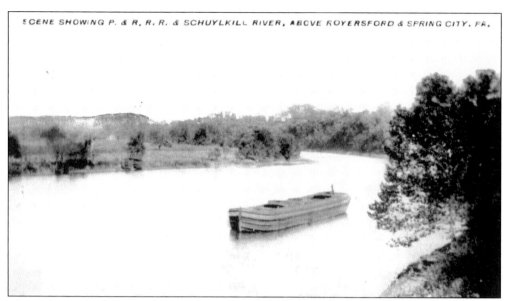

The early postcard view above shows a canal boat on the river above Royersford. After the Schuylkill Navigation Company system was opened in 1824, one could travel from Pottsville to Philadelphia. Spring City, a canal town at that time, was actually called Springville and did not get its current name until 1872. The boats carried people and products north and south. Industries such as the paper mill came to town, and people followed. The development of this small town was directly related to the opening of the Schuylkill Canal.

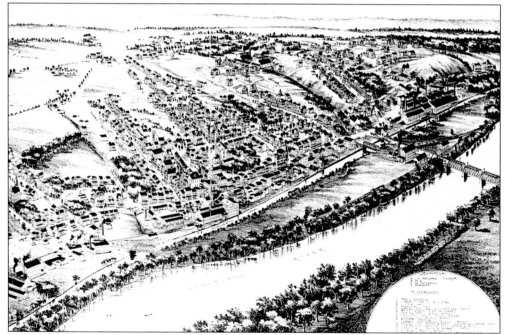

In this 1893 overview of Spring City, one can see the Schuylkill Canal and the river as it passes by the town. The growth of industry along the canal is quite evident, as is the settlement of people. The Pennsylvania Railroad started service in 1879 and served as one of the town's primary means of transportation.

This picturesque view overlooking the Schuylkill River was taken from Brown Drive in Spring City. Its vantage point shows Parker's Ford and the area where George Washington and his army crossed the river in September 1777.

Lover's Lane, Spring City, Pa., leading to New State Hospital.

"Lover's Lane" is a commonly used postcard theme. It seems that every town had one, and every publisher felt the need to publish one. All that is usually depicted is a dirt road and some trees, as in this view of Church Street leading to the Pennhurst State School in Spring City. This area is in the vicinity of Pierre Bezallion's cave, and it is the starting point for recent searches to uncover the cave.

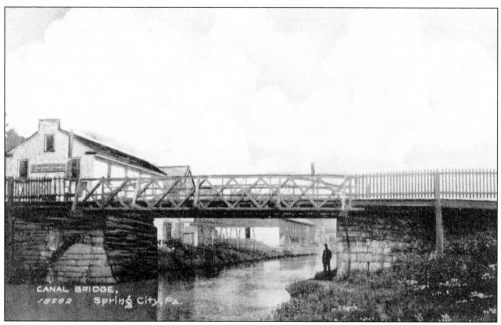

This 1905 view was taken from the towpath on the banks of the canal in Spring City. The building to the left was the home of the *Spring City Sun,* the local newspaper. Behind the canal bridge are some of the buildings of the American Paper Company. Although the paper company business had ended, the Shafting Works acquired the property at this time and began a new industry.

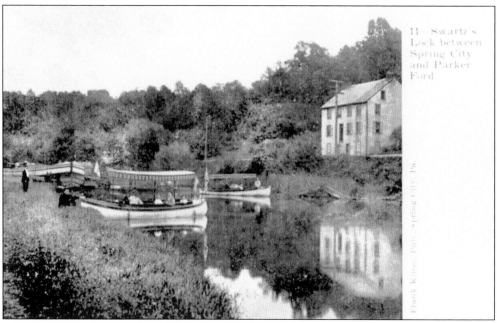

A summer photograph of the Schuylkill Canal at Swartz's Lock between Spring City and Parkerford shows two pleasure boats and a large canal boat loaded with cargo on its round trip to Philadelphia. The canal was frozen over for several months during the winter, and the only activity one might find on it was ice-skating.

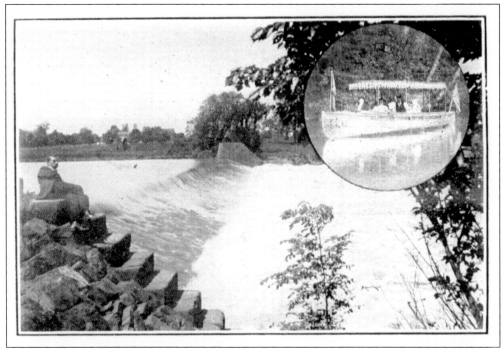

Located above Spring City, Yankee Dam, or Vincent Dam, was 342 feet in length. It was one of the two local dams that were constructed on the river prior to the opening of the canal. The other dam was Black Rock Dam, located below Royersford. The Schuylkill Navigation Company created a series of canals on both sides of the river. The canal boats navigated on long stretches of the river. This type of travel was possible only with the use of the dams that could keep the river levels high enough to use.

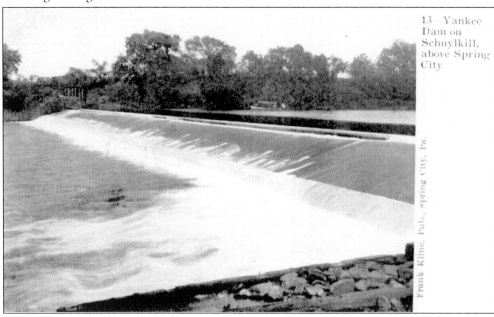

13—Yankee Dam on Schuylkill, above Spring City

Frank Kline, Pub., Spring City, Pa.

Illustrated here is a popular "greetings" format used by many local postcard publishers. They designed a postcard that would enable them to display many local views in miniature. This type of "greetings card" doubled as advertisement for their own cards.

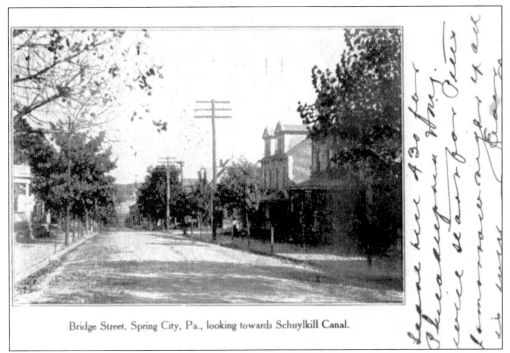

Bridge Street, Spring City, Pa., looking towards Schuylkill Canal.

This 1905 view looks down Bridge Street Hill in Spring City. It is interesting to note that the caption on this postcard reads, "Looking towards the Schuylkill Canal." The canal at this time was a central point of reference.

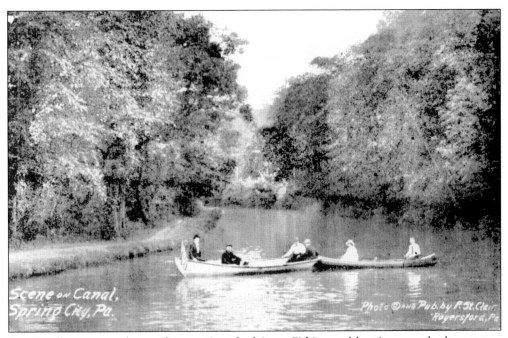

Scene on Canal, Spring City, Pa.

Photo © and Pub. by F. St. Clair, Royersford, Pa

Sunday afternoon on the canal was a time for leisure. Fishing and boating were both common all along the canal. Unlike the river, with its swirls and swift current, the canal was a calm and peaceful place to relax in a small boat.

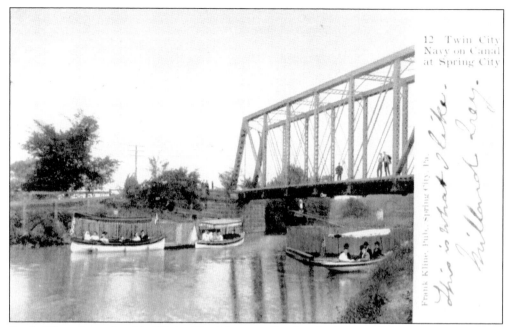

Frank Kline chose the title "Twin City Navy on Canal at Spring City" for this 1907 postcard that he published. The postcard's reference to the two towns as the "twin cities" shows just how early this terminology was used. The iron bridge in the photograph was one of the Pennsylvania Railroad bridges that crossed over the canal.

The old mill dam, a body of water in Spring City located near the railroad track bed, can be seen from higher ground on Church Street. It was created during the construction of the Pennsylvania Railroad as soil was moved and areas backfilled to run the railroad into Spring City. This Pennsylvania Railroad line was opened in 1884.

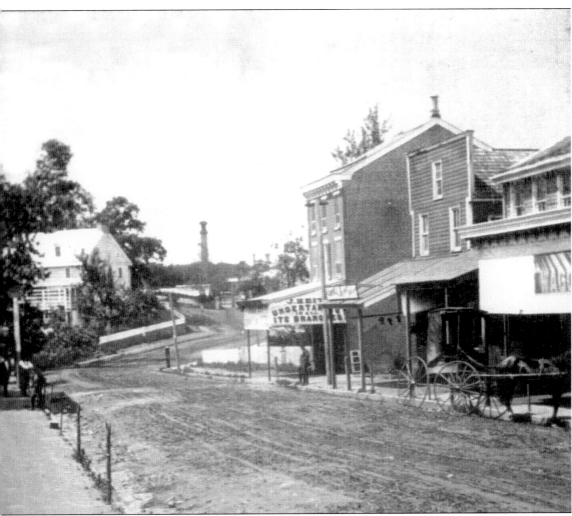

In this 1890 view, the large farmhouse that belonged to Frederick Yost, a prominent Chester County landowner who chose to live in Spring City, can be seen. Yost's house was located on Main Street at the bottom of Yost Avenue, which was named after him. Many years later, this would be the location of the Valley Forge Flag Company. The large pipe structure in the background was the watering pipe used by the Pennsylvania Railroad. In the foreground stands the original pump where travelers could stop to quench their thirst.

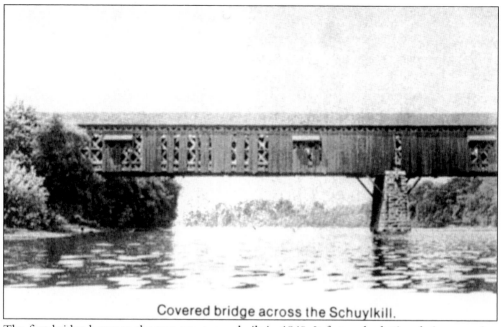

Covered bridge across the Schuylkill.

The first bridge between the two towns was built in 1840. It featured a lattice-design covering similar to the one pictured here, the Lawrenceville covered bridge at Linfield. It is no coincidence that this toll bridge was built the year after the Philadelphia and Reading Railroad began operations in Royersford.

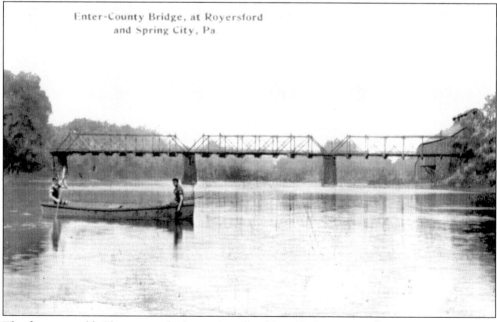

Enter-County Bridge, at Royersford and Spring City, Pa

The first covered bridge was washed away in a flood just 10 short years after its construction and was replaced by similar wooden structure. This covered bridge was swept away by fire in 1884 and was replaced by the iron bridge that was called "the permanent bridge."

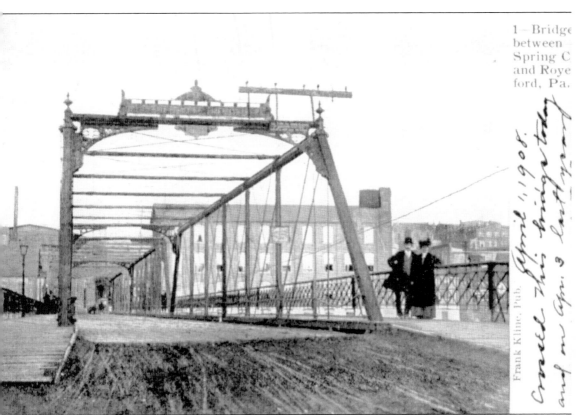

Frank Kline, Pub.

*Crossed this bridge today
and on Apr. 3 last year.*

April 1, 1908.

In this view, the old iron bridge that linked the two towns can be seen. Frank Kline and his wife are posed to the right in this photograph. Kline was a local Spring City merchant who had a jewelry store on Main Street and also published postcards. He was not camera-shy and appeared on several other postcards that he published during this time. The old covered bridge that once connected the two towns burned down in 1884. This new iron bridge that was supposed to last forever was erected in its place. The bridge was built by the Phoenix Bridge Company in nearby Phoenixville, and the beams were brought up to Spring City on the canal.

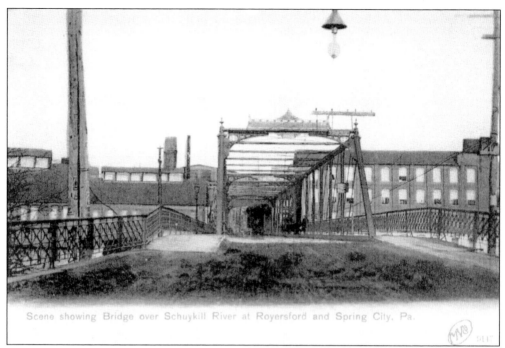

Scene showing Bridge over Schuykill River at Royersford and Spring City, Pa.

On the day of the dedication of the new iron bridge, there was a celebration with music and festivities. The bridge was roped off, and a local band played music as the dancing went on into the evening. The bridge was made out of iron, and many called it "the permanent bridge." This bridge did not last as long as many had thought it would. In 1922, it was removed, partly because of the scant maintenance it had received over the years.

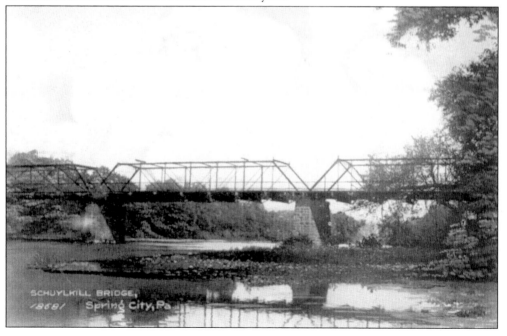

SCHUYLKILL BRIDGE,
Spring City, Pa.

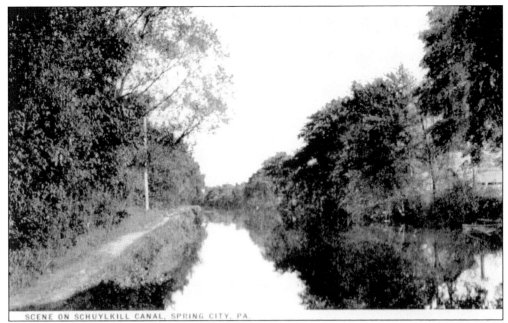

SCENE ON SCHUYLKILL CANAL, SPRING CITY, PA.

The towpath along the side of the old canal is in plain view on the left side of this picture. A man would lead his mules down the towpath, pulling the canal boats along. While the canal played a great part in the early development of the area, it was only a few short years later that the railroads would follow the Schuylkill, just as the old canal had done 20 years earlier. In 1870, after the canal business had peaked, the canal was leased to the railroad.

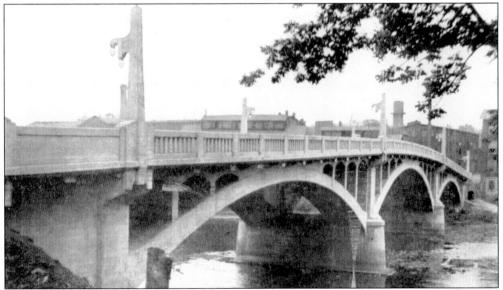

This view of the cement bridge was taken in the 1950s. In a joint project, Chester County and Montgomery County saw the completion and opening of this bridge in 1922. The bridge replaced the old iron one that had been dismantled. Two of the patented "Phoenix beams" that once held the old iron bridge together are now in the Spring-Ford Area Historical Society's museum. They are not only a historical exhibit but also the main structural support beams for the museum building.

21

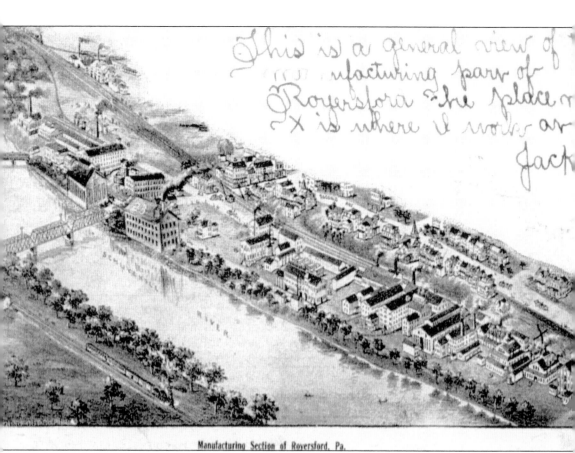

This is a general view of [m]anufacturing part of Royersford. The place [where] X is where I work as Jack

Manufacturing Section of Royersford, Pa.

In this *c.* 1905 view, the industrial development that had taken place in Royersford is evident. The title of the postcard is "Manufacturing Section of Royersford." Several stove factories, including Buckwalter, Floyd Wells, and Grander, are visible. There are two glassworks, hosiery mills, the Keystone Meter Company, the spring factory, and the Royersford Machine Works, just to name a few. Most of this industry was located on First Avenue, along the banks of the Schuylkill river, and served by the Philadelphia and Reading Railroad.

Two

Transportation

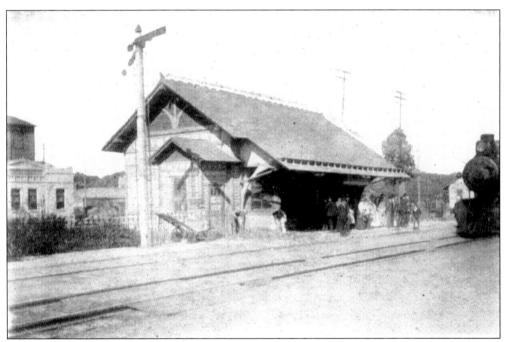

Spring City and Royersford were blue-collar towns, and at the beginning of the 20th century, most people walked to work. They did not have private transportation, as we have today. Some had horses, and there was a stagecoach that came through town. The canal was one of the first means of public transportation. The railroads followed, with the Reading Railroad opening in Royersford and the Pennsylvania Railroad in Spring City. In 1899, the trolley began operating in Spring City. The trolley service was quite popular and gave people an economical way to get around. One of the favorite trips in the summer was the ride out to Bonnie Brae Park on the open-air trolley. In 1924, the trolley service ended, and in 1930 bus service began. By this time, the use of automobiles was very common, and many people owned them.

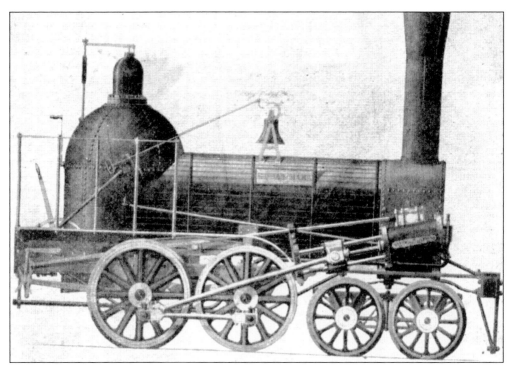

The first train to pass through Royersford, in 1839, was a Philadelphia and Reading Railroad train that was pulled by a Gowan and Marx steam engine, as shown here. It is interesting to note that the train was 80 cars long and carried 1,635 barrels of flour, 23 tons of pig iron, 6 tons of coal, 2 hogsheads of whiskey, and 60 passengers in the 2 cars at the rear of the train.

The original Royersford station was located at the bottom of Main Street Hill. Schwenk's Tavern was one of the establishments located near the rail line that had applied for a ticket franchise. It was awarded the contract, and the old tavern building seen to the left in this photograph served as the station for 91 years.

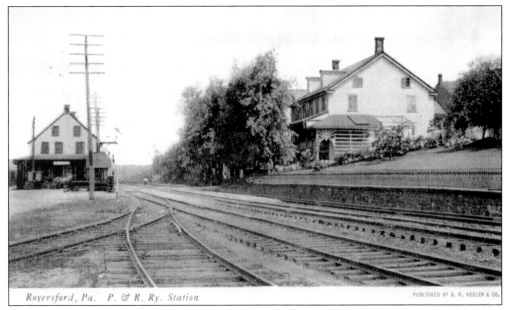

Royersford, Pa. P. & R. Ry. Station PUBLISHED BY R. H. KEELER & CO.

The original Royersford station is shown above on the left. The numerous sidings that branched off to the First Avenue industries are in the foreground. The Reading Railroad replaced the old station in 1932 and held an opening-day celebration in April of that year. The new station is shown below in a 1950s postcard view.

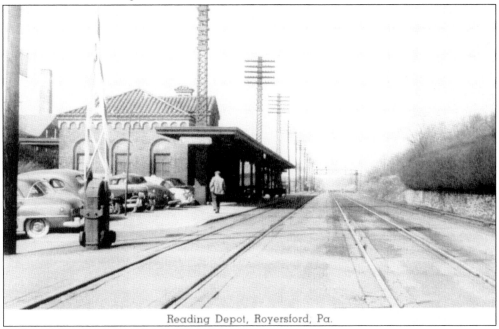

Reading Depot, Royersford, Pa.

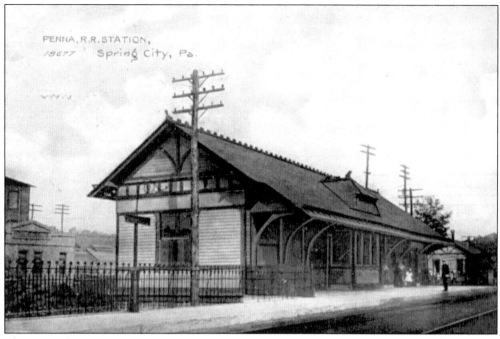

The Pennsylvania Railroad station in Spring City was completed in 1884, and the first train passed through in September of that year. Ten years later, in 1894, the ladies room was added, and in 1906, the entire building was enlarged. In this photograph, the freight station can be seen to the far right.

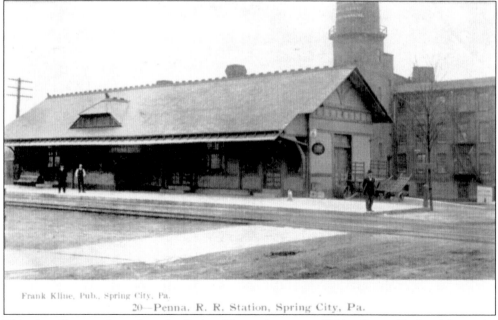

This view illustrates how close the Spring City station was to Bridge Street. To the right can be glimpsed the Spring City Knitting Mills. This station sat abandoned for years after the rail service had ended and was finally torn down in 1970.

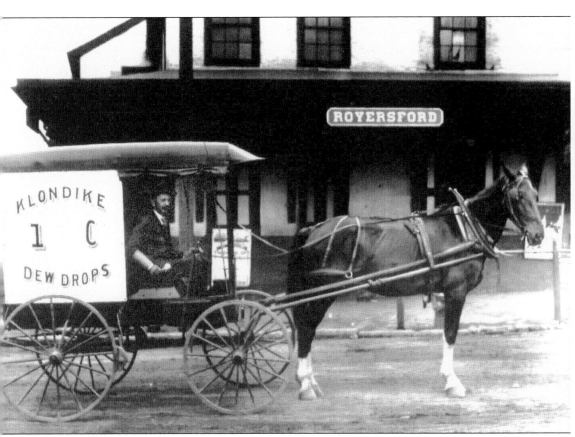

An ice-cream wagon is stopped *c.* 1920 in front of the Royersford train station. This was a sight to see, as the old horse-drawn wagon slowly made its way up the hill with the sound of its bell clanging in the air. Children with a couple of pennies in hand would come running to buy a cone from the "dewy man." A nickel would get you a double dip, for those who could afford the luxury. In the early 1920s, Patrick Kirkpatrick from Spring City operated a route selling "dew drops."

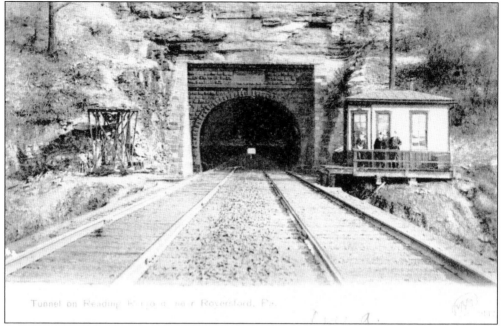

Tunnel on Reading Railroad near Royersford, Pa.

Black Rock Tunnel was constructed and opened in 1839 by the Philadelphia and Reading Railroad. On the railroad's main line, it lies between Phoenixville and Royersford and is still in operation today under the ownership of the Norfolk and Southern Railroad. It has been enlarged twice and is currently operated as a single-track tunnel.

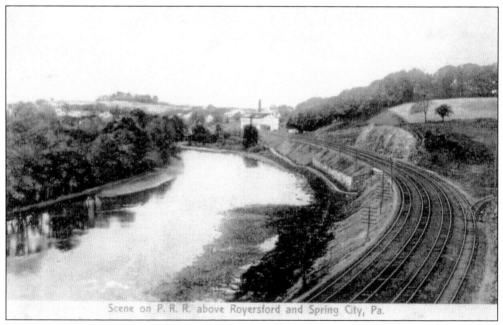

Scene on P. R. R. above Royersford and Spring City, Pa.

This is one of many scenes of the railroad as it followed the Schuylkill River, the Reading Railroad on the Royersford side and the Pennsylvania Railroad on the Spring City side. The Reading Railroad crossed over the Schuylkill just before entering Black Rock Tunnel, so that when it arrived at Columbia Station in Phoenixville, it was on the Chester County side.

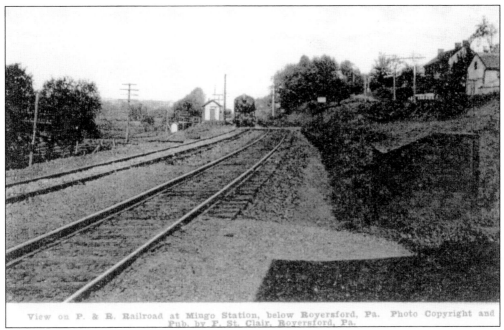

View on P. & R. Railroad at Mingo Station, below Royersford, Pa. Photo Copyright and
Pub. by F. St. Clair, Royersford, Pa.

Mingo Station was a small stop on the Philadelphia and Reading Railroad below Royersford, and if you blinked you might miss it. Frank St. Clair, a local Royersford merchant, published many postcards, including these two railroad postcards. The railroads were a favorite subject of the photographers back then, as they are today.

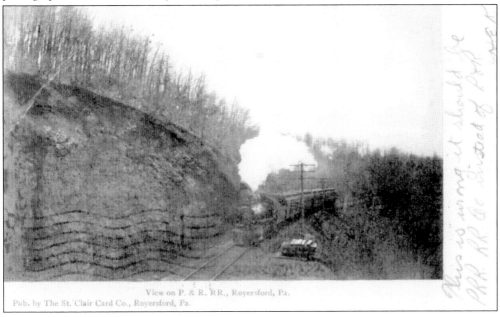

View on P. & R. RR., Royersford, Pa.
Pub. by The St. Clair Card Co., Royersford, Pa.

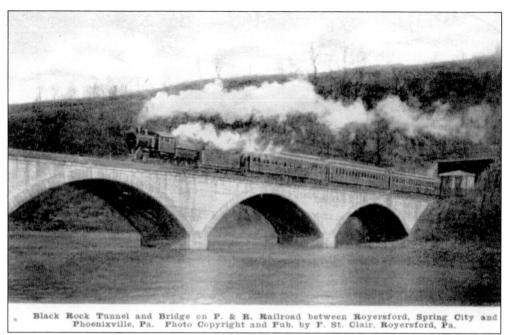

Black Rock Tunnel and Bridge on P. & R. Railroad between Royersford, Spring City and Phoenixville, Pa. Photo Copyright and Pub. by F. St. Clair, Royersford, Pa.

This passenger train has just minutes earlier left the Reading Railroad station in Phoenixville. The station, also known as Columbia Station, is a short distance from Black Rock Tunnel. As the train comes out of the tunnel, it crosses over the Schuylkill River into Montgomery County and heads toward Royersford.

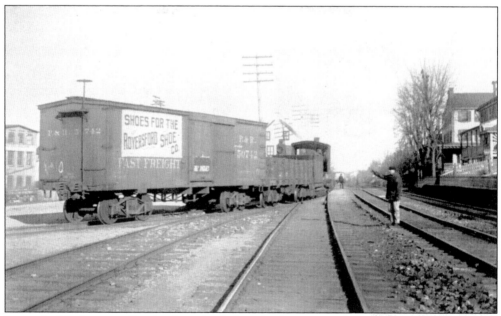

Royersford had many railroad sidings that led to the factories spread out along the river. In this *c.* 1898 photograph, a private boxcar is being dropped off on a siding. The wording on the side of the Philadelphia and Reading Railroad car reads, "Shoes for the Royersford Shoe Company Fast Freight."

30

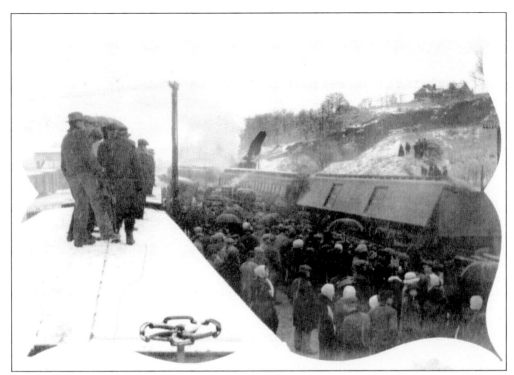

In these two views are seen the wreckage of a passenger train accident that occurred on the Reading Railroad above Royersford in 1914. It had collided with a coal train in the morning, and many of the local people from town walked up to the site upon returning from work that evening.

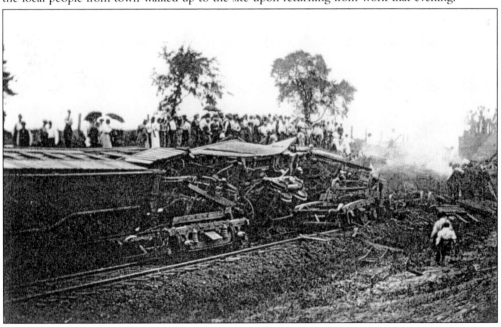

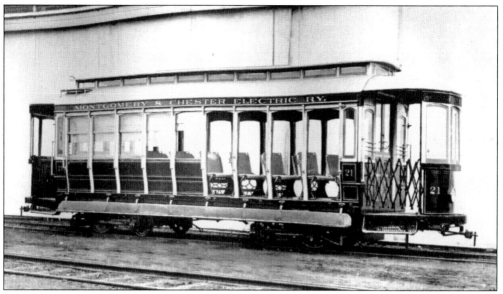

The open-air trolley was a favorite during the summer months. The Montgomery and Chester Railway Company had one such trolley, pictured above. It was known simply as the Spring City trolley. It made regular round trips between Spring City and Phoenixville. During the summer, one of the favorite destinations was Bonnie Brae Amusement Park, located just outside of town.

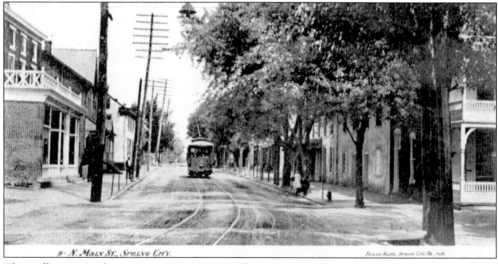

The trolley service began operation in 1899. The route started on Main Street and went down through town. It then turned right on Walnut Street and went up the hill, passing by the trolley barn at Cedar Street. The tracks then turned left, went one block over Pikeland Avenue, and followed this road out of town to the main road that went to Phoenixville.

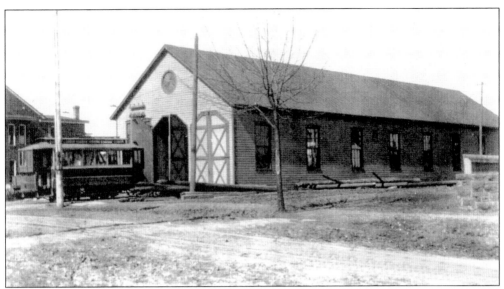

Located at Walnut and Cedar Streets in Spring City, the trolley barn was completed in 1899. Power for the trolley line was provided by the Schuylkill Valley Illumination Company.

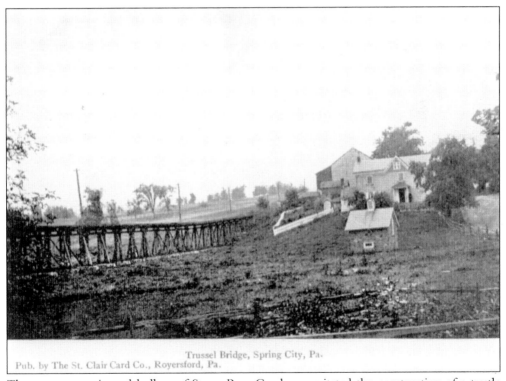

Trussel Bridge, Spring City, Pa.
Pub. by The St. Clair Card Co., Royersford, Pa.

The uneven terrain and hollow of Stony Run Creek necessitated the construction of a trestle bridge to get the trolley tracks out to the Schuylkill Road, the main highway that ran between Spring City and Phoenixville.

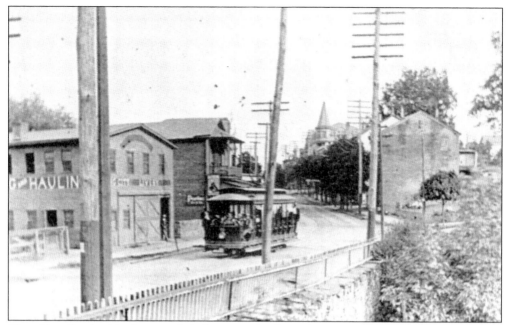

The old trolley in this photograph is shown at the foot of Yost Avenue, directly across from the old Spring City shoeing forge and livery stable on Main Street. The original plans for the trolley route included building a bridge to cross the river to Montgomery County, upstream from the existing iron highway bridge. Such a bridge was never built.

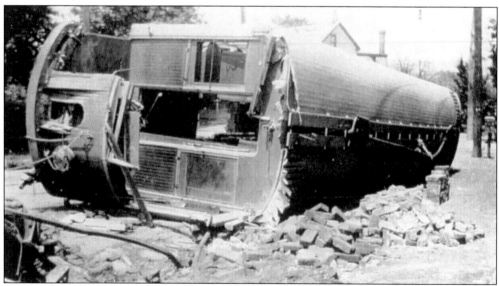

On July 8, 1924, a trolley accident occurred at the foot of Walnut Street. A brake failure caused the accident, which left the old trolley on its side and the automobile of Oliver Place a wreck. This was not the only brake failure that occurred, but it was the one that marked the end of trolley service. For 25 years, the trolley had served the town, but 1924 marked the end of an era. Bonnie Brae Amusement Park would close just three years after the trolley service ended.

The Pennsylvania Railroad came through Crab Hill north of town in what was known as the Crab Hill cut. Pennhurst State Hospital was located in this area. In these views, the cut and the Schuylkill Canal are visible.

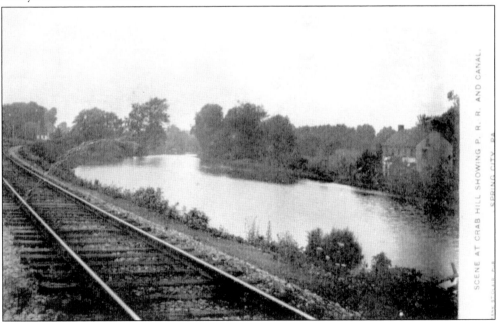

SCENE AT CRAB HILL SHOWING P. R. R. AND CANAL. SPRING CITY, PA.

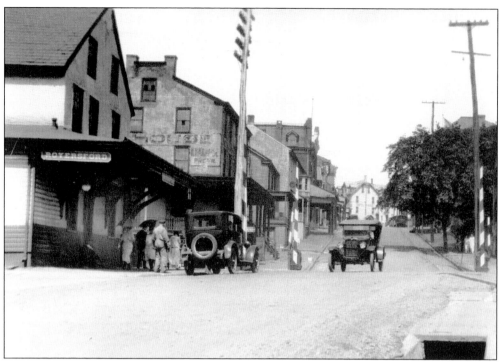

The original Royersford station sat at the bottom of a hill. It was located on Main Street at the crossing gates. The American House, visible in this photograph, was located directly across the tracks from the station. As one can see, time had taken its toll on this old tavern. Just a couple of blocks up the hill sits the Hotel Freed, where many travelers spent the night.

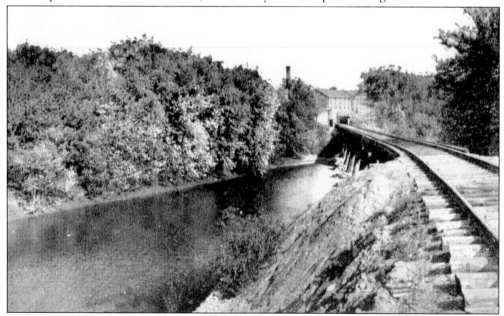

The Pennsylvania Railroad completed work on this river bridge in 1892. It was used for a siding to connect with the Royersford industries located all along First Avenue. The freight customers would now have another shipper, and the Reading Railroad would have some competition.

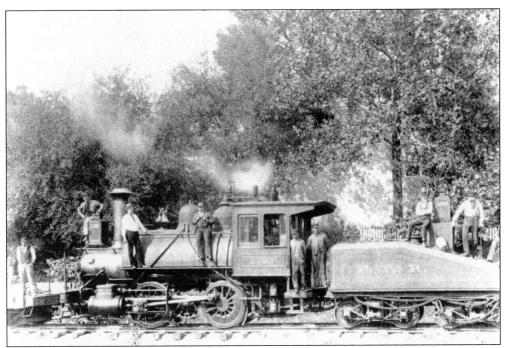

The Pennsylvania Railroad had to cross over the canal more than once. In 1891, the G.S. Bennett and Company Glass Works started operations behind Cedar and Bridge Streets in Spring City. A siding had to be run that crossed the canal and followed the hollow up to the factory. In this photograph, a Pennsylvania Railroad switcher engine and a work crew attending to the No. 2 siding at the glassworks are shown. Another point where the main line of the railroad in Spring City crossed the canal is shown below.

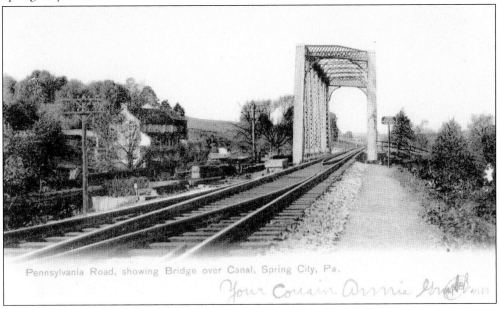

Pennsylvania Road, showing Bridge over Canal, Spring City, Pa.

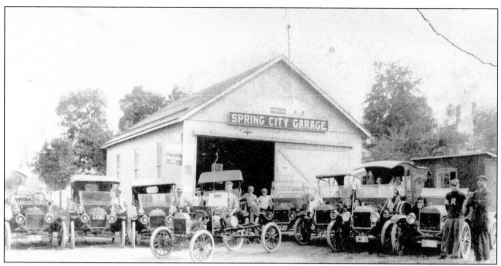

The Spring City Garage was located on Central Avenue behind the Methodist church in Spring City. Automobile sales and repairs were conducted at this location for a number of years.

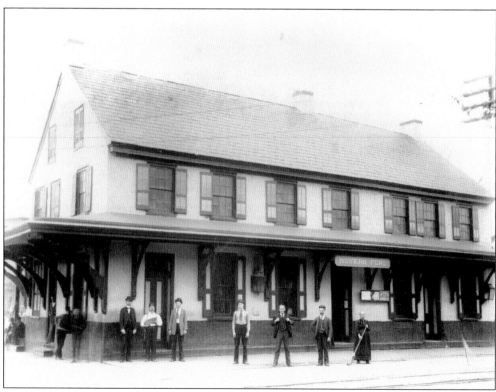

In this very early photograph of Schwenk's Tavern (which was by then selling tickets for the Philadelphia and Reading Railroad), one can see that the sign out front still features the original name of Royer's Ford. Looking a little closer, one can see that of all the people in the photograph, there is but one woman, holding a broom.

Three

INDUSTRY

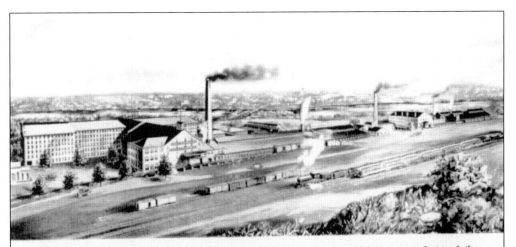

The Plants of BUCKWALTER STOVE CO., Royersford, Pa., in which are manufactured the celebrated Apollo and Canopy Ranges, Ringgold Heaters and Eclipse Furnaces. These Plants rank among the largest and best equipped stove foundries in the United States and were established in 1865.

In the early 1900s, the industrial growth of the two towns was reaching a peak. There were glassworks, knitting and hosiery mills, brick works, lumberyards, stove works, and many more manufacturing facilities. One major manufacturer, the American Paper Company in Spring City, had already run its course and closed in 1893. This local industry began in 1847 and was in continuous operation for 46 years. In 1904, the property was leased to the Pennsylvania Shafting Company, and a new industry started up. Of all the manufacturing industries in the two towns, one type stood out above all the rest. Stove manufacturing was the leader, with various concerns located on both sides of the river. Spring City had the Schuylkill Valley Stove Works, Yeager and Hunter's Stove Works, and the Royal Stove Company. Royersford had the Buckwalter Stove Company, the Grander Stove Company, and the Floyd Wells Stove Company. There were other smaller companies, and many of these major companies were given different names when their ownership was reconfigured.

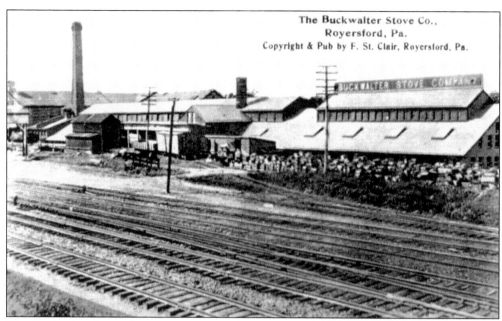

The Buckwalter Stove Co.,
Royersford, Pa.
Copyright & Pub by F. St. Clair, Royersford, Pa.

The Buckwalter Stove Company, in Royersford, was established in 1865. In its earlier years, it manufactured cherry seeders made from cast-iron parts, horse-powered treadmills that were used by farmers, and other cast-iron products. The Eclipse cook stove was introduced in 1871, and the Buckwalter stove industry was off to a fast start. In 1889, the Buckwalter brothers, Joseph and Henry, acquired complete control of the operation. Joseph Addison Buckwalter served as the president of the company.

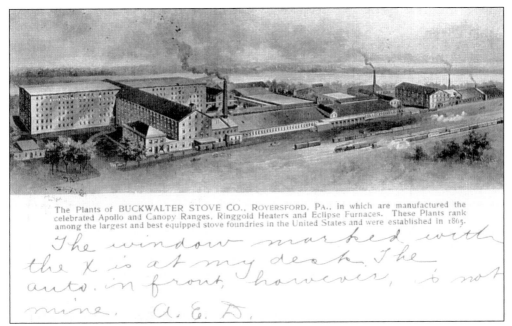

The Plants of BUCKWALTER STOVE CO., ROYERSFORD, PA., in which are manufactured the celebrated Apollo and Canopy Ranges, Ringgold Heaters and Eclipse Furnaces. These Plants rank among the largest and best equipped stove foundries in the United States and were established in 1865.

The window marked with the X is at my desk. The auto. in front, however, is not mine. A. E. D.

The Buckwalter Stove Company was served by the Philadelphia and Reading Railroad with numerous sidings, as can been seen in both of these views. The company manufactured Apollo and Canopy ranges as well as Ringgold heaters and Eclipse furnaces. These products were shipped out by rail to destinations all over the country. Operation continued until 1930, when the Great Depression helped close the doors for the last time. The Buckwalter Stove Company employed 300 people at one time.

A SCENE IN ROYERSFORD, PA.

DIAMOND GLASS COMPANY
MANUFACTURERS OF
BOTTLES AND VIALS
ROYERSFORD, · · PENNA.

1909		NOVEMBER			1909	
SUN	MON	TUE	WED	THR	FRI	SAT
-	1	2	3	4	5	6
7	8	9	10	11	12	13
14	15	16	17	18	19	20
21	22	23	24	25	26	27
28	29	30	-	·	·	·

Advertising postcards were common. Shown here is a 1909 calendar postcard from the Diamond Glass Company in Royersford. The company was incorporated in 1894. It manufactured glass bottles that were, at that time, all blown by hand. In 1924, the operation was updated, and mass-produced bottles were made by automated machines. This glassworks remained in operation until 1990.

9763—A WINTER SUNSET
COPR. W. H. SANFORD THE KNAPP CO. N.Y.

Standard Grocery Company
Royersford, Pa.
General Store

1913		January				1913
SUN	MON	TUE	WED	THR	FRI	SAT
			1	2	3	4
5	6	7	8	9	10	11
12	13	14	15	16	17	18
19	20	21	22	23	24	25
26	27	28	29	30	31	

The Standard Grocery Company operated a store on Main Street in Royersford, as seen in this advertising postcard calendar from 1913.

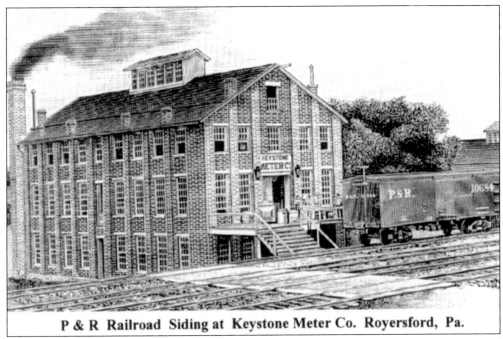

P & R Railroad Siding at Keystone Meter Co. Royersford, Pa.

Gas meters were manufactured in Royersford as early as 1889. In 1891, the operation was acquired by the Keystone Meter Company. This *c.* 1898 view shows a Philadelphia and Reading boxcar on a siding at the Keystone Meter Company on First Avenue.

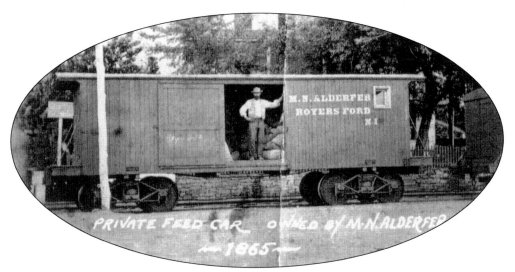

This is an 1865 photograph that was published on a 1905 postcard. It shows a private feed car belonging to M.N. Alderfer of Royersford. It could be Alderfer posing on the old wooden boxcar, but there are no records of this early business. In fact, the only information about it has been preserved on this one postcard.

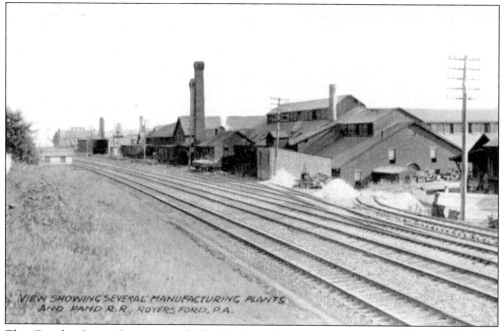

The Grander Stove Company and the Floyd Wells Stove Company were located on First Avenue in Royersford, two blocks down from the Buckwalter Stove Company. Grander started manufacturing stoves in 1880, and Floyd Wells began operation in 1883.

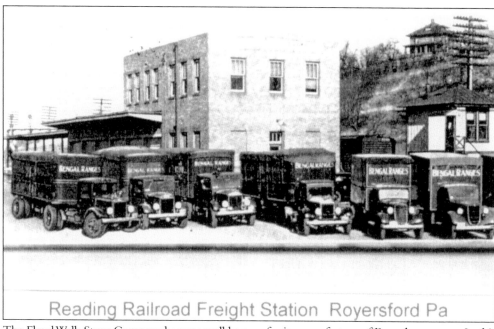

The Floyd Wells Stove Company became well known for its manufacture of Bengal gas ranges. In this photograph, the Bengal gas range truck fleet is lined up in front of the Royersford freight station.

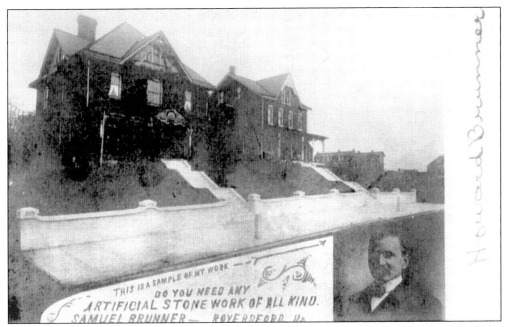

Throughout the town of Royersford in the early 1900s, the work of Samuel Brunner could be seen in many places. Brunner was a skilled craftsman who specialized in concrete structures and operated the Royersford Cement Works. In these early photo postcards advertising his work, we see some of his creations.

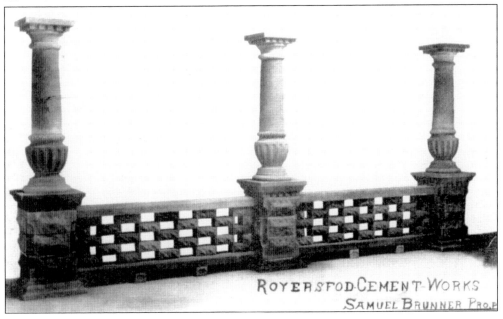

With most manufactured products, there follows a steady stream of advertising to help with sales. The stove industry provided a wealth of material, from early Victorian trade cards to the postcards shown here.

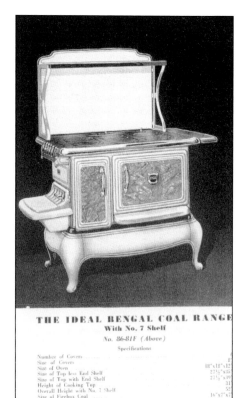

THE IDEAL BENGAL COAL RANGE
With No. 7 Shelf
No. 86-81F (Above)
Specifications

Number of Covers	8
Size of Covers	8
Size of Oven	18"x18"x12"
Size of Top less End Shelf	27½"x35"
Size of Top with End Shelf	27½"x39"
Height of Cooking Top	31
Overall Height with No. 7 Shelf	52
Size of Firebox Coal	16"x7"x5"
Floor Space with End Shelf	47"x35"
Shipping Weight (Crated)	475 lbs

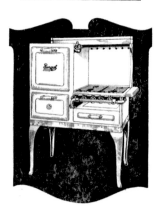
The old stoves were originally all black cast iron, but in later years colored enamel finishes were developed. These new brightly colored stoves were an advertiser's delight and helped the salesman by making the stoves more appealing to the eye.

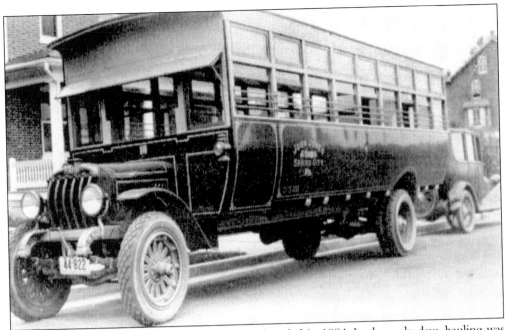

The Jones Motor Company of Spring City was founded in 1894. In the early days, hauling was done with a horse and wagon. The first motor truck was purchased in 1912, and the motor fleet began. This photograph shows a Jones motor bus, used to transport employees to and from the Schuylkill Valley Mills on South Main Street in Spring City.

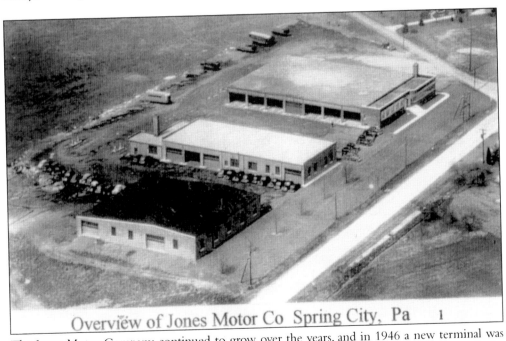

Overview of Jones Motor Co Spring City, Pa 1

The Jones Motor Company continued to grow over the years, and in 1946 a new terminal was constructed at the corner of Bridge Street and Schuylkill Road in Spring City. By 1960, the company had become one of the largest carriers in Pennsylvania. The terminal is shown here shortly after its completion.

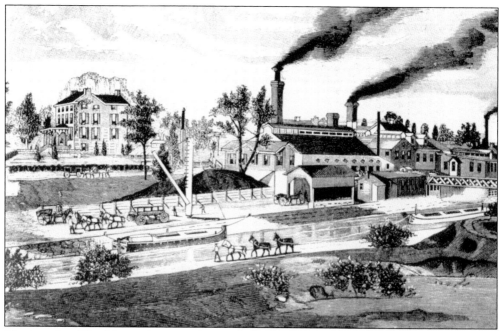

The American Wood Paper Company dates back to 1847, when the firm of Shyrock and Company purchased land along the canal in Spring City. Raw materials came in on the canal, and the finished product, high-quality paper used primarily for calendars, was shipped out on the canal.

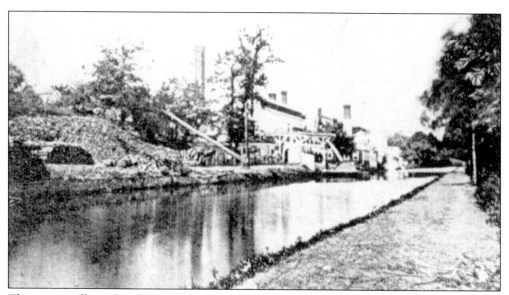

The paper mill employed more than 125 people at the peak of production, but the business slowed as raw materials became more difficult to find and the cost to transport them increased. The mill was closed in 1893 and sat idle for a number of years.

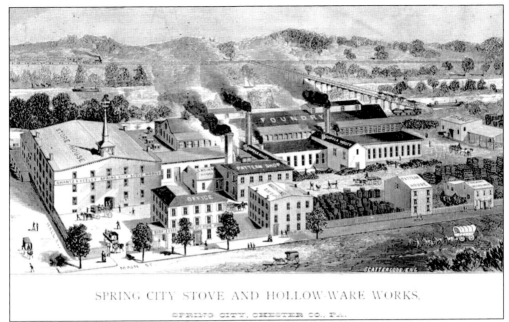

SPRING CITY STOVE AND HOLLOW-WARE WORKS,
SPRING CITY, CHESTER CO., PA.

The Spring City Stove Foundry has a long history going back to 1843, when James Rogers started to manufacture wood-burning stoves. It also was one of the original canal-born industries. Over the years, the ownership and name of the business changed several times. In 1870, the large stove works shown here was owned by Shantz and Keeley.

This wood-burning stove was one of the earliest stoves manufactured in Spring City and dates from 1845. "J. Rogers Springville" appears on the front cast-iron plate of the stove. The foundry made many cast-iron products, such as kettles and waffle irons, but the manufacture of stoves and stove parts was its principal business.

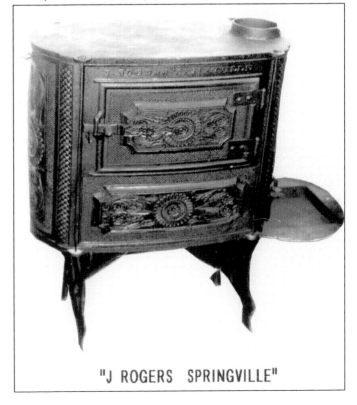

"J ROGERS SPRINGVILLE"

49

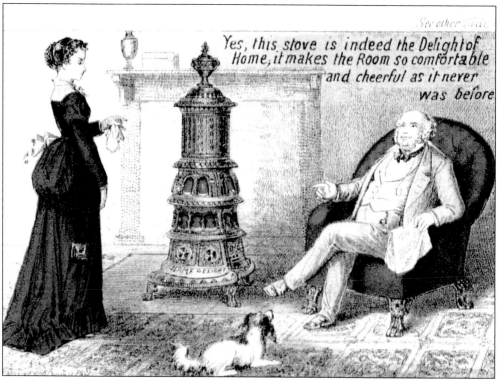

Yes, this stove is indeed the Delight of Home, it makes the Room so comfortable and cheerful as it never was before

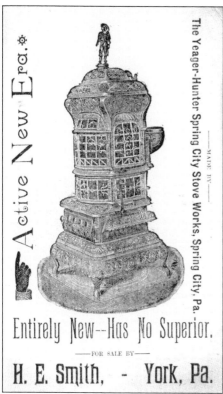

Active New Era.

The Yeager-Hunter Spring City Stove Works, Spring City, Pa.

—MADE BY—

Entirely New--Has No Superior.

—FOR SALE BY—

H. E. Smith, - York, Pa.

"The Home Delight" was featured on this early Victorian trade card for the Shantz and Keeley Stove Company, shown above. The stoves were manufactured in Spring City and shipped out by canal and rail to distant places. In 1883, the stove-manufacturing business had new owners and became the Yeager and Hunter Stove Company. H.E. Smith of York, Pennsylvania, was the local sales representative for the Yeager and Hunter Stove Company.

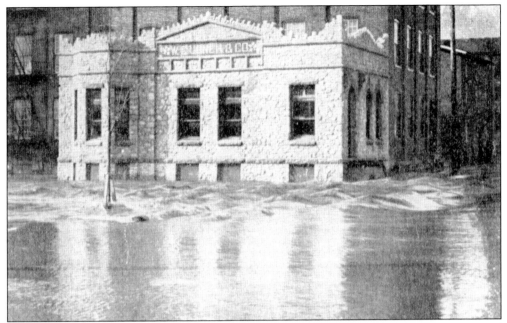

In 1901, another major flood hit the two towns. In this view are the offices of W.C. Urner and Company, with floodwaters halfway up to the first-floor windows. The Urner Company hosiery mill was located on Bridge Street in Spring City.

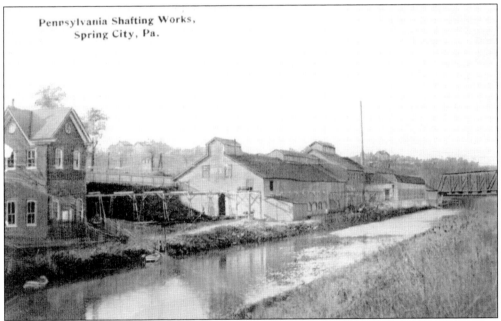

The Pennsylvania Shafting Works, in Spring City, began operation in 1904, when the old paper mill property was leased to a new business. In this view of the mill, one can see the canal. To the right is the iron railroad bridge that was constructed by the Pennsylvania Railroad that same year to service this new industry.

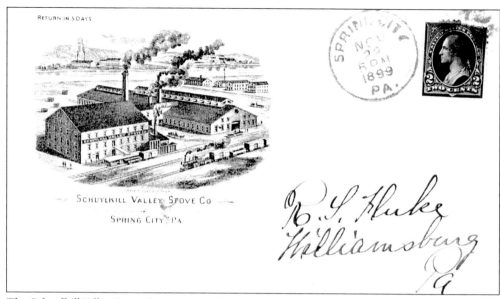

The Schuylkill Valley Stove Company was located on South Main Street in Spring City. A view of the manufacturing plant is depicted on this 1899 letterhead. Keep in mind that an artist's sketch can be deceiving and is often used to enhance and perhaps exaggerate the presentation.

ITHACA GLASS MFG. CO.
SPRING CITY, PA.

Manufacturers and Jobbers Of

Florentine	**WINDOW GLASS**	Polished Plate
Ground		Mirrors
Chipped	**QUOTATIONS**	3-16 Crystal
Moss		Wire Glass
Colonial	90-25% S. S.	Leaded Glass
Rippled	90-30% D. S.	Wind Shields

OFF LIST MARCH 1st, 1913. f. o. b. cars Spring City

The Ithaca Glass Company was one of the last companies to utilize the glassworks originally known as the G.S. Bennett Company. Located in Spring City behind Cedar and Bridge Streets, this business did not manufacture glass. It shipped bulk loads of window glass in by rail and then cut it down to smaller sizes and marketed it to stores.

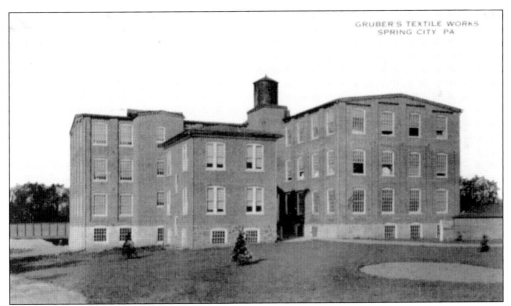

Gruber's Textile Mills were located at Main and Popular Streets in Spring City. The Spring City Knitting Company was founded in 1907, and this building was constructed in 1909. The main product manufactured was underwear, but the company did produce shirts for the U.S. Army during World War I.

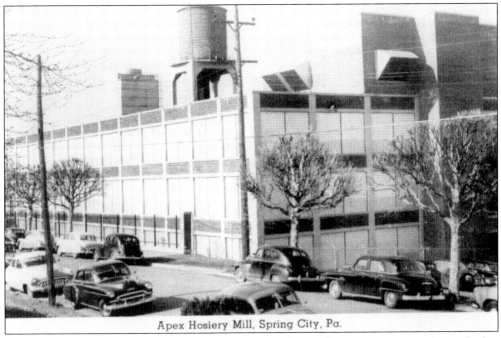

Apex Hosiery Mill, Spring City, Pa.

The Apex Hosiery Mill was formerly the Schuylkill Valley Mills. Beginning operation at Spring City in 1920, Schuylkill Valley Mills employed 250 people by 1926. It merged with Apex in 1949, just five years before it closed. Philco Tube, a division of Philco Ford Company, later used this building.

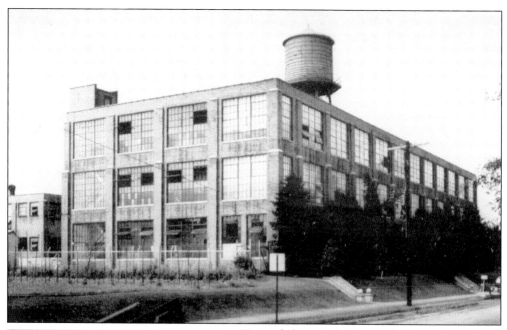

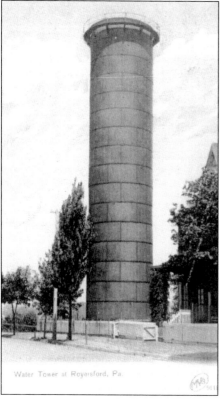

Water Tower at Royersford, Pa.

Pictured above is the Royersford Needle Works, a business that came to Royersford in 1917. The building on Walnut Street was constructed in 1922. The plant manufactured Spring Beard needles, which were used in the manufacture of hosiery. In the postcard view at the left, the standpipe belonging to the Home Water Company is shown. This pipe was constructed in 1890 and was located at the corner of Fourth Avenue and Chestnut Street in Royersford. The 80-foot structure was removed in 1916.

Four

SCHOOLS AND
INSTITUTIONS

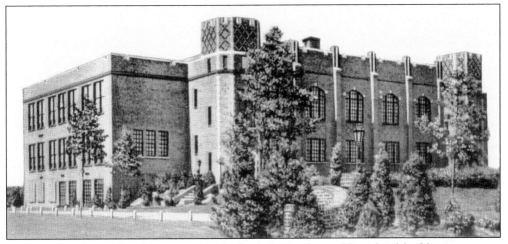

In the early 1800s, education was privately funded. The first public school buildings were not erected until the 1870s. In Royersford, the first school within the borough limits was erected in 1871 on the corner of Fifth Avenue and Church Street. The Adams School, on Fourth Avenue, was built in 1892. Across the river in Spring City, the Church Street School, at the corner of Church and Broad Streets, was erected in 1872. Later on, the Bridge Street School was built, and in 1928 construction on the New Street High School was begun. In the picture above, one can see the unique architectural design of this school, which makes it resemble a castle. Unfortunately, it has been torn down. In 1891, the Liberty Steam Fire Engine Company of Spring City was formed. The Humane Steam Fire Engine Company of Royersford was organized in 1883. Royersford saw the official organization of a second fire company in 1897, when the Friendship Hook and Ladder and Hose Company was formed. The Pennhurst State School and Hospital in Spring City was opened in 1908. It was a state institution for the mentally handicapped and at one time had more than 3,000 patients. The hospital has since been closed, and most of the buildings remain empty today.

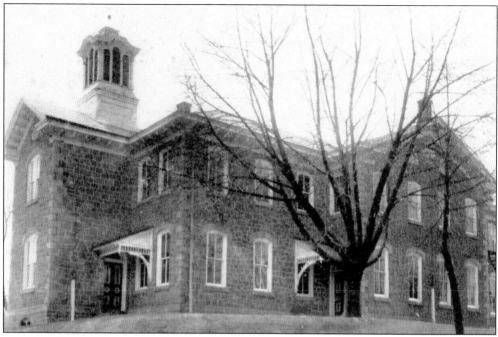

The first public school in Spring City was held at the Lyceum building at Hall and Main Streets. In 1849, classes were moved to the Union Meeting House and later to a small school building behind the old Lutheran church. It was not until 1872 that the Church Street School was constructed. This brownstone building was enlarged in 1892 and was big enough to house all 12 grades. In 1929, the high school on New Street opened, and the Church Street School became a grade school. Both of these buildings are now gone.

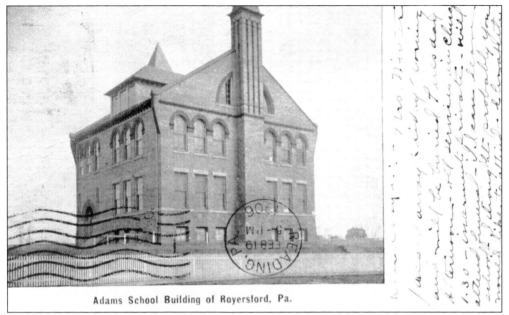

Adams School Building of Royersford, Pa.

The Adams Street School in Royersford was constructed in 1892 on a large lot at Fourth Avenue and Washington Street. Although the building was spacious in its time, the population expansion made it necessary to build a new school on the property. This new grade school opened in 1930 and sat alongside the Adams building. The old Adams Street School was eventually removed.

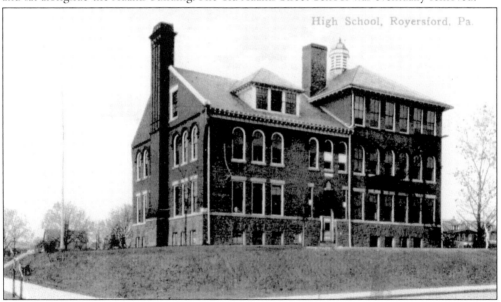

High School, Royersford, Pa.

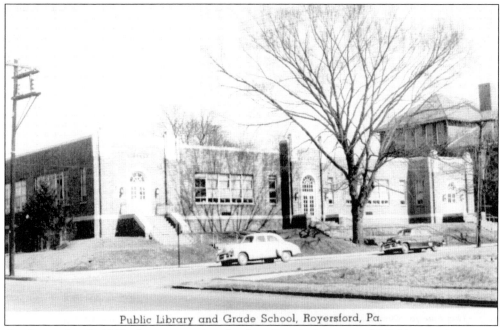

Public Library and Grade School, Royersford, Pa.

On September 8, 1930, the new grade school at Fourth Avenue and Washington Street was opened. In this 1950s postcard view, the old Adams School can be seen in back of the new grade school. The Royersford Public Library is now housed in this school building.

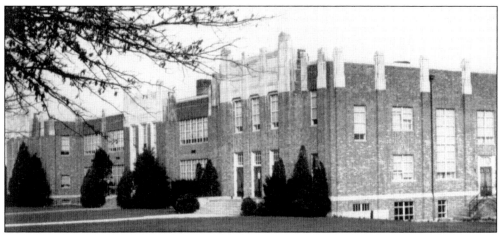

The fall of 1931 saw the official opening of the new Royersford High School. This junior-senior high school was located at Seventh Avenue and Washington Street.

58

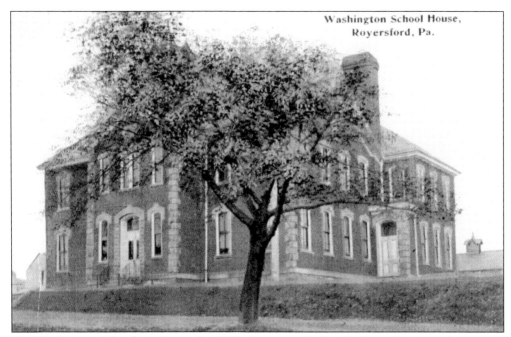

Over the years, sports teams from both towns have had their share of glory. Championships won by local teams helped contribute to community pride. In this early-1900s postcard view, the Royersford football team poses for a team photograph.

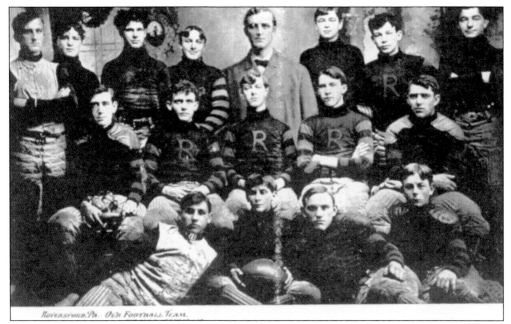

The Washington School was located at Fifth Avenue and Church Street in Royersford. It was erected in 1871 by Limerick Township. It was a one-story building consisting of a single room. In 1883, the building was enlarged, and in 1889 four more rooms were added. This photograph was taken long after all the modifications had been completed.

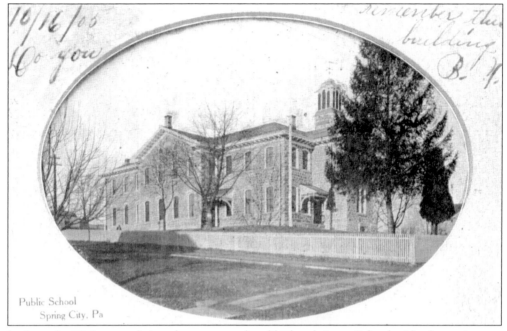

Public School
Spring City, Pa

In the early-1905 postcard view above, we see the old Church Street School with a large pine tree in front. For many years, this was the location of the community Christmas tree. After the school was removed, a parsonage for the Methodist church was built at this location. Pictured below is the Bridge Street School that opened in 1906. This school, located at the corner of Bridge and Penn Streets, has been the home of the Spring-Ford Rescue Squad in recent years.

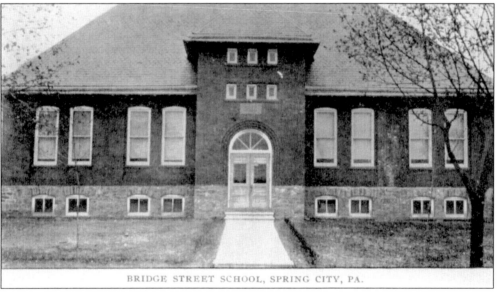

BRIDGE STREET SCHOOL, SPRING CITY, PA.

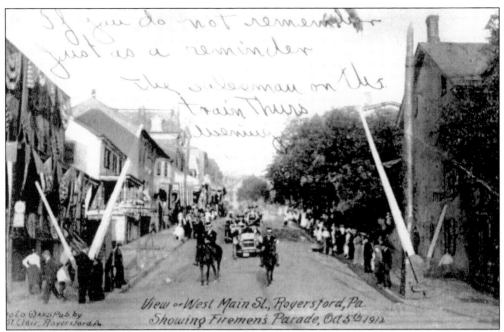

View on West Main St., Royersford, Pa.
Showing Firemen's Parade, Oct 5th 1912

Above, the firemen's parade has just reached the bottom of Main Street Hill in Royersford on October 5, 1912. This parade would cross over the river bridge and go on into Spring City. Firemen's parades were common and usually marked the acquisition of new equipment or the dedication of a new building. In this case, Friendship Hook and Ladder had just acquired a new fire apparatus. The view to the right shows the original Friendship firehouse, on Green Street.

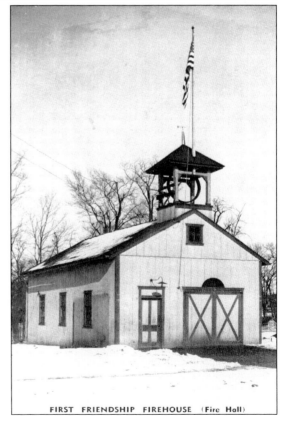

FIRST FRIENDSHIP FIREHOUSE (Fire Hall)

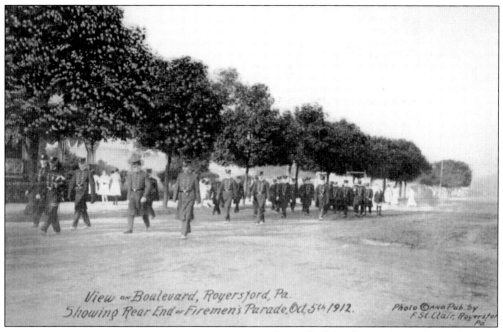

View on Boulevard, Royersford, Pa.
Showing Rear End of Firemen's Parade, Oct. 5th 1912.

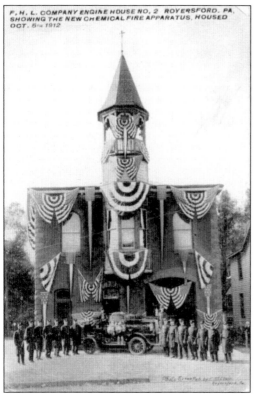

F. H. L. COMPANY ENGINE HOUSE NO. 2 ROYERSFORD. PA.
SHOWING THE NEW CHEMICAL FIRE APPARATUS, HOUSED
OCT. 5th 1912

The end of the firemen's parade on the boulevard in Royersford is shown here. The original firehouse on Green Street was removed, and a larger brick structure was constructed in 1905 to replace it. It was built in part by volunteers of the company. In 1906, a horse-drawn wagon was purchased. In 1912, a new chemical fire apparatus was housed and is shown to the left.

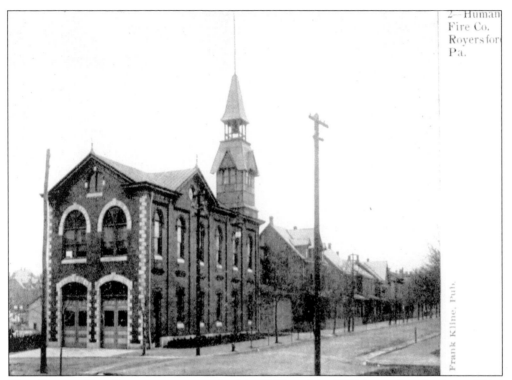

Frank Kline, Pub.

The Humane Fire Company was organized in 1883, and in 1885 it purchased a lot at Third Avenue and Walnut Street in Royersford. The first firehouse, a frame structure, was completed that same year. In 1898, the new brick structure pictured here was completed, and a dedication was held in May 1898.

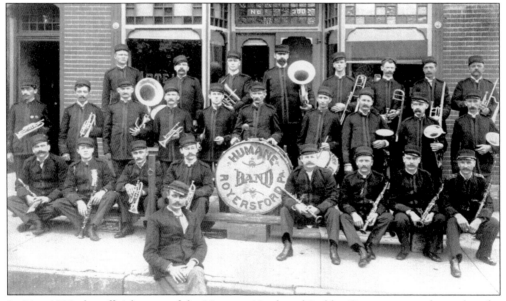

In May 1885, the official name of the Humane Hook and Ladder Company was changed to the Humane Steam Fire Engine Company. The company purchased a new Button engine that year at a cost of $1,850. The band was chartered in April 1889.

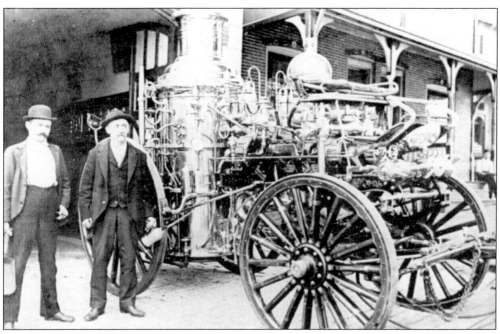

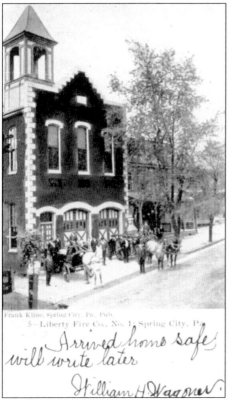

5—Liberty Fire Co., No. 1, Spring City, Pa.

Arrived home safe; will write later

William H Wagoner

In 1882, the Spring City Borough Council purchased a new firefighting apparatus from the Silsby Manufacturing Company in New York at a cost of $3,600. This action was the result of a fire that destroyed the Shantz and Keeley Stove Works in July 1881. The Liberty Steam Fire Engine Company No. 1, a volunteer firefighting organization, was incorporated in 1882. The firehouse was built at the bottom of Hall Street in 1892.

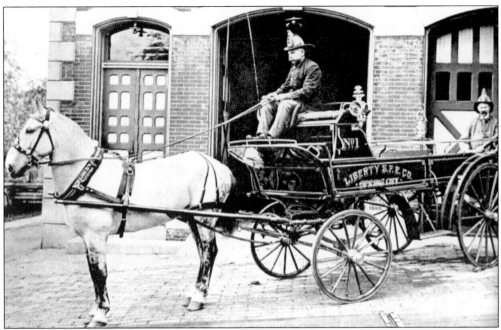

The first firehouse in Spring City, built in 1881, was located at Hall and Church Streets. It was later used as the borough hall. This building is no longer in existence, but the new borough hall was built on the same spot. Depicted here is some of the early firefighting equipment employed by the Liberty Fire Company.

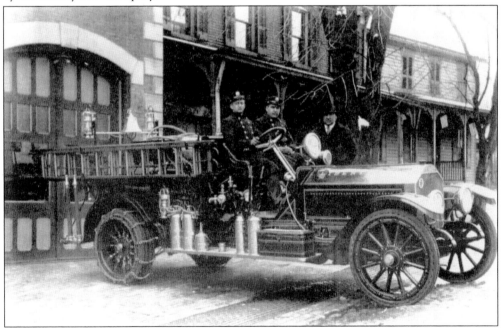

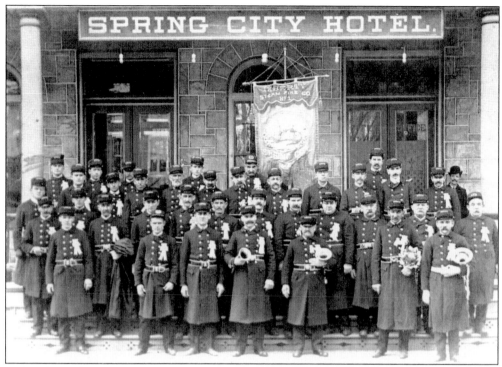

In the above photograph, members of the Liberty Steam Fire Engine Company No. 1 Band are posed in front of the Spring City Hotel. This band marched in parades and played at community functions throughout the area. In the picture postcard view below, a firemen's band is shown rounding the corner at Bridge and Main Streets in Spring City. The Liberty Band marched in this firemen's parade of 1912.

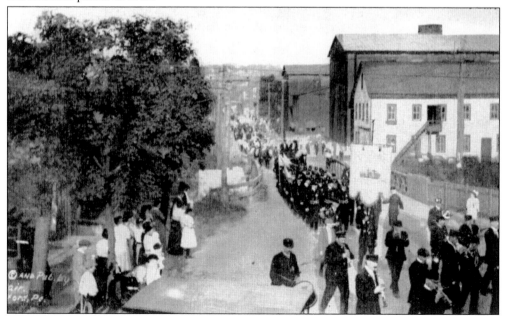

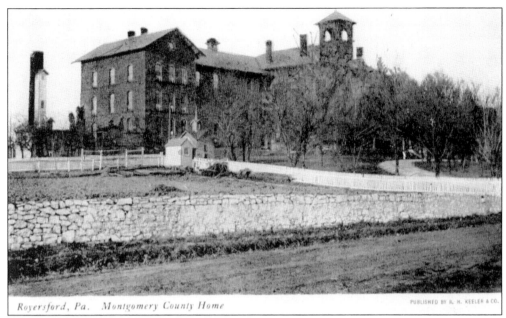

The Montgomery County Home is located on the east bank of the Schuylkill River in Upper Providence Township, near Royersford. Sometimes referred to as the Johnson home, this three-story structure was completed in 1872. The original frame house was erected in 1808 and was more commonly called the county poorhouse.

Country Home, Royersford, Pa.

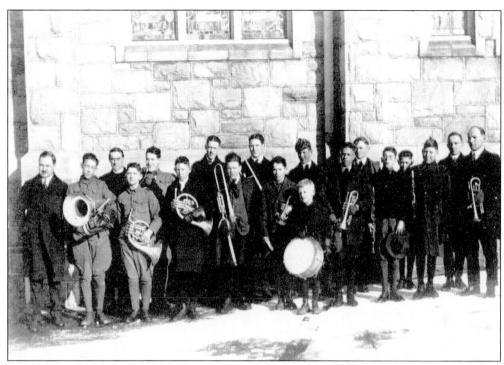

Standing in front of the Methodist church *c.* 1918 are the members of the Spring City Boy Scout Band. The local fire company and the schools also had bands. The Pennhurst State School had its own band as well. In those days, one could imagine who was left to watch a parade.

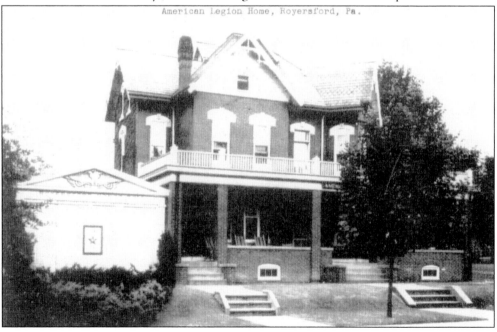

The American Legion building in Royersford is pictured here. Post No. 164 was started in 1919 at the end of World War I. It was named the Captain Harris D. Buckwalter Post for the first serviceman from town to lose his life in the war.

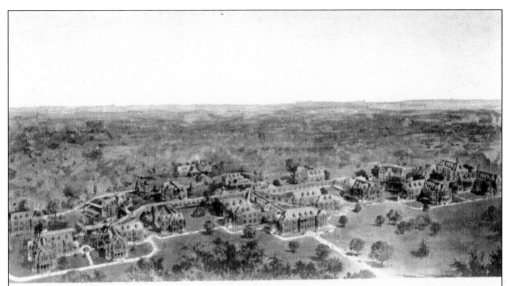

16—Hospital for Feeble Minded and Epileptics now building at Spring City, Pa.

Sitting high atop Crab Hill, looking down on the Schuylkill River, there was a community that was separated from the rest of Spring City: the Pennhurst State School and Hospital. A sprawling complex of red brick buildings, it included a dairy farm, powerhouse, greenhouses, movie theater, laundry, cafeteria, and many other facilities. Most of these buildings were connected by underground tunnels, making it possible to pass from building to building without ever seeing the light of day.

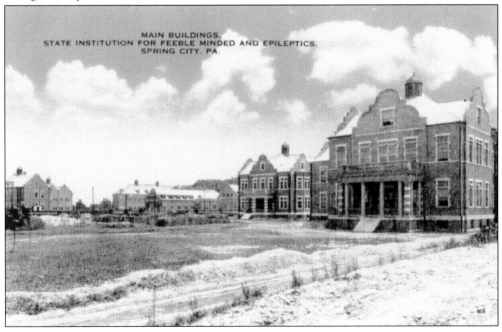

MAIN BUILDINGS,
STATE INSTITUTION FOR FEEBLE MINDED AND EPILEPTICS.
SPRING CITY, PA.

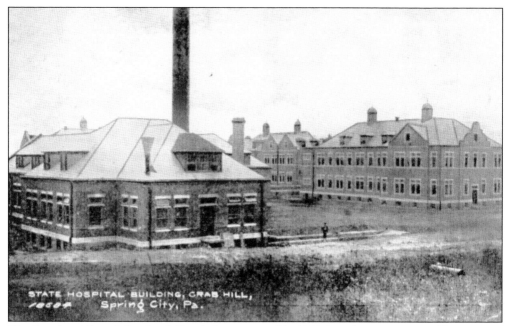

The Pennhurst State School and Hospital was opened in 1908. Pennhurst was created by an act of legislation in 1903 and was officially opened in November 1908. In the postcard view below, the children's cottages can be seen. Patients were separated from each other according to a number of categories. Men were separated from women; the lower-functioning were separated from the higher-functioning patients; and wards, such as crib wards and locked wards, housed different types of patients.

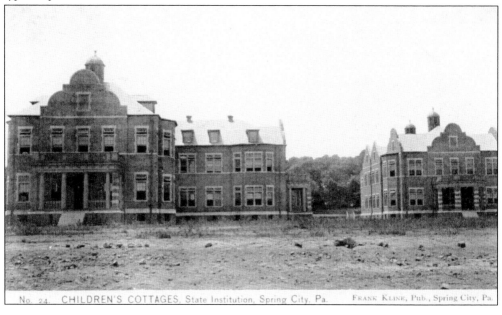

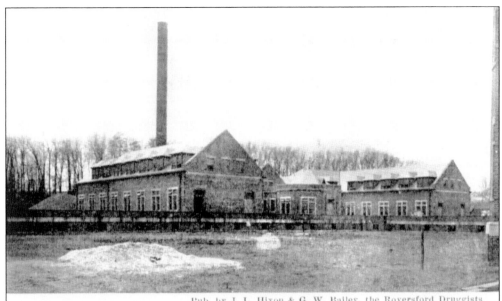

DINING-ROOM BUILDING, EASTERN PA. STATE INSTITUTION FOR FEEBLE-MINDED AND EPILEPTIC, PENHURST STATION, SPRING CITY, PA.

Shortly after Pennhurst was opened, many postcard views of it were published. It was a very large institution with an assortment of buildings to photograph. Many of these cards refer to the institution as being for "the feeble-minded and epileptic," reflecting the terminology used in 1908. The dining room is pictured above, and the boys' cottage is shown below.

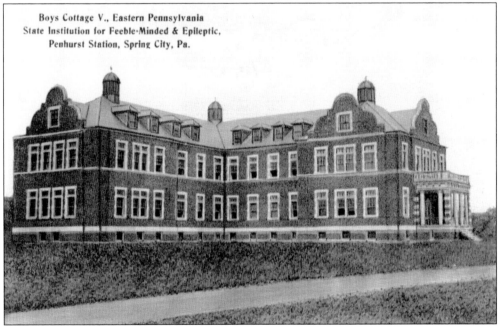

Boys Cottage V., Eastern Pennsylvania State Institution for Feeble-Minded & Epileptic, Penhurst Station, Spring City, Pa.

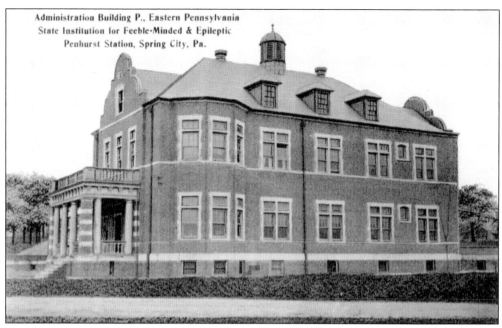

Administration Building P., Eastern Pennsylvania
State Institution for Feeble-Minded & Epileptic
Penhurst Station, Spring City, Pa.

These two postcard views show the Pennhurst State School and Hospital. The administration building, shown above, was called Building P. It is interesting to note that all the buildings had a corresponding letter designation. Low Grade Cottage Q is shown below. Pennhurst closed in the late 1980s, and most of its clients were placed in group homes or other state facilities.

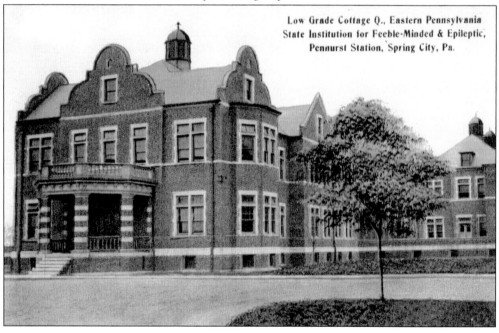

Low Grade Cottage Q., Eastern Pennsylvania
State Institution for Feeble-Minded & Epileptic,
Pennurst Station, Spring City, Pa.

Five

MAIN STREET

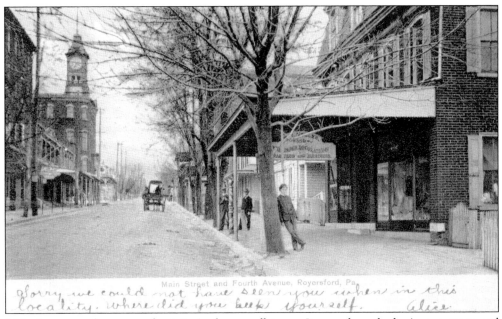

Main Street and Fourth Avenue, Royersford, Pa.

Sorry we could not have seen you when in this locality. Where did you keep yourself. Alice.

Main Street was the center of activity in these small towns. It was where the businesses, stores, and banks were located. Whether it was on a walk to the post office or the local market, people would often stop on Main Street and talk to their friends and neighbors. In Royersford, the town hall, complete with a clock tower, was located on Main Street. The National Bank of Royersford and the Home National Bank were both on Main Street. The Old Opera House, the Hotel Freed and the railroad station were on Main Street, along with many other small establishments. Spring City also had its stores and shops on Main Street, as well as a large industrial development at the lower end of town on South Main Street. The National Bank of Spring City, the Gem Theatre, the Spring City Hotel, and Mowery Latshaw Hardware were but a few of the many establishments that were downtown on Main Street.

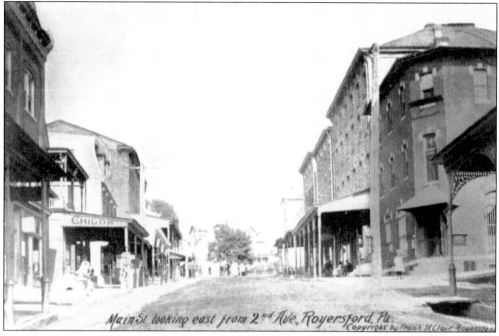

This *c.* 1905 view of Royersford looks east from Second Avenue. To the right at the upper corner of Second Avenue sits the Home National Bank. The Industrial Savings Bank also operated out of this building. Many of these businesses and stores had frontal protective roof structures going right out to the curb, much like the one seen here on Child's (left).

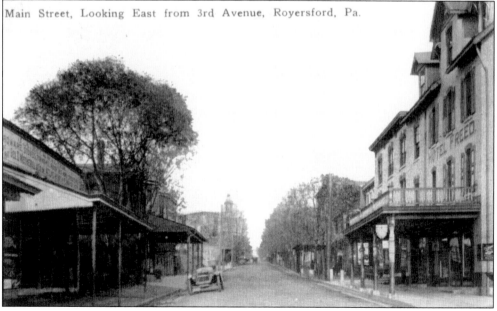

Taken at Third Avenue, this photograph shows the J.A. Buckwalter store (left) and the Hotel Freed (right). Near the top of the hill at Fourth Avenue and Main Street sits the town hall.

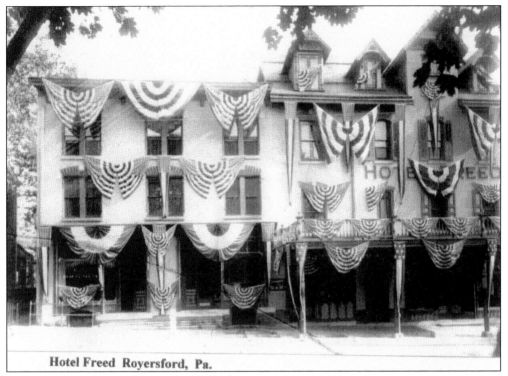

Hotel Freed Royersford, Pa.

The Hotel Freed sat on the corner of Third Avenue and Main Street in Royersford. A.C. Freed was the proprietor. In the view above, the hotel is draped and decorated for a Fourth of July parade and celebration. The hotel was torn down in 1928 to make room for a new bank. The Royersford Opera House was opened in January 1897 and played host to vaudeville acts, plays, and other special events. In 1909, it was reopened under new management and began showing moving pictures. It later changed names and was known as the Penn Theater. After the theater closed, the building was occupied by Allen's Variety Store. This building was removed in 1976.

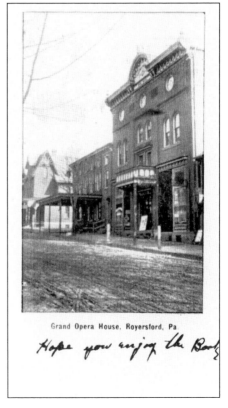

Grand Opera House. Royersford, Pa

Hope you enjoy the Book

75

The above photograph shows 437 Main Street, the home of the Royersford Shoe Company. John Milton Lewin was the proprietor.

The image to the left shows the town hall. Originally known as Latshaw's Hall, this building sits at the corner of Fourth Avenue and Main Street in Royersford. Samuel R. Latshaw built it in 1880, and the clock tower was added a few years later. Although the building remains today, the tower was declared unsafe and was removed in 1970.

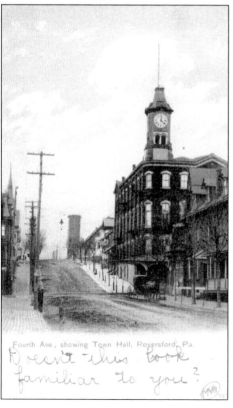

Fourth Ave., showing Town Hall, Royersford, Pa.

Doesn't this book familiar to you?

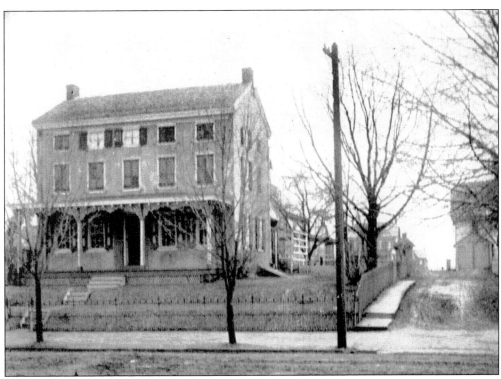

The William Lewin Plantation House, located at 526 Main Street, is the fourth oldest house in Royersford. It was built in 1861 by William Lewin and remained as the family homestead for many years. Chester Rogers acquired the property in 1910 and made many changes. Today this historic property is owned and operated by the Spring-Ford Area Historical Society. There are two museums, a cobbler shop, and an art gallery on the premises.

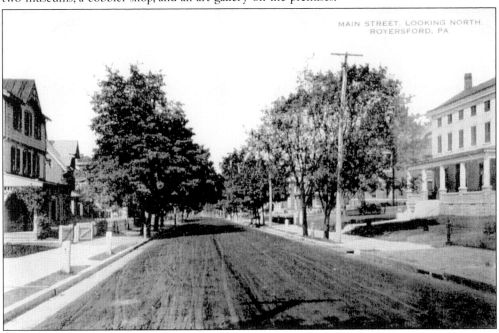

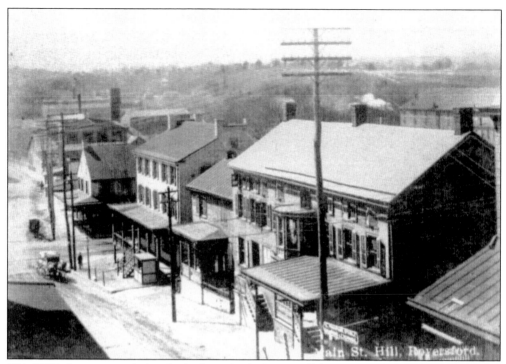

This 1905 photo postcard view looks down Main Street Hill from Second Avenue. The American House tavern and the railroad station are both in view at the bottom of the hill.

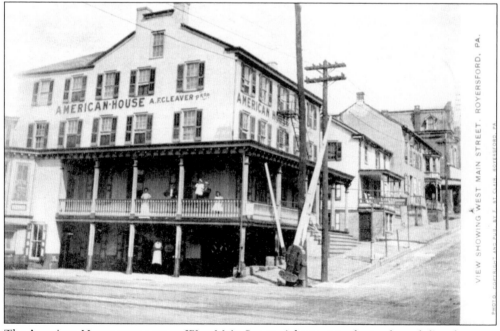

The American House tavern sat on West Main Street, right next to the tracks and directly across from the train station. A.F. Cleaver was the proprietor at the time of the photograph, and his name is painted on the face of the building.

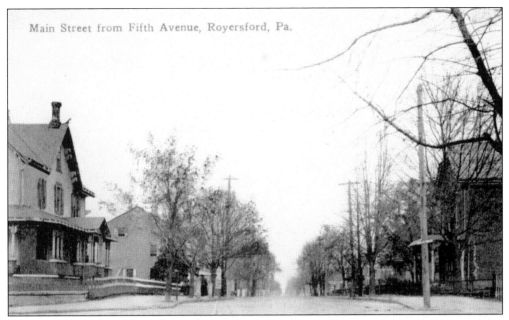

Main Street from Fifth Avenue, Royersford, Pa.

The above view shows Main Street from Fifth Avenue in Royersford. The image to the right shows the Home National Bank. This bank was organized in June 1892. The building sits on the corner of Second Avenue and Main Street in Royersford. It is still there, but its banking days are long gone.

Trust Co. Building, Royersford, Pa

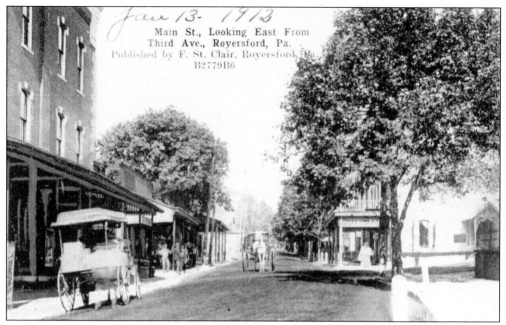

Jan 13- 1913

Main St., Looking East From
Third Ave., Royersford, Pa.
Published by F. St. Clair, Royersford, Pa.
B2779B6

Main Street is pictured in a view looking east from Third Avenue in Royersford. This 1912 postcard was published by Frank St. Clair. A vendor's cart is parked along the curb.

This view looks down Main Street Hill in Royersford. The postcard was published by J.L. Hixon and G.W. Bailey, Royersford druggists.

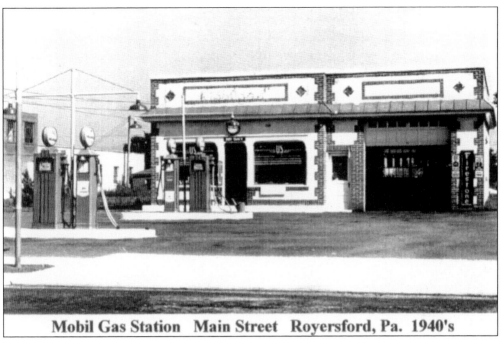

Mobil Gas Station Main Street Royersford, Pa. 1940's

A typical 1940s small-town gas station is depicted in the above view. This Mobil station stood on Main Street in Royersford. Below, a 1950s-era postcard view looks up Main Street in Royersford. To the far left, Savage's television and appliance store can be seen.

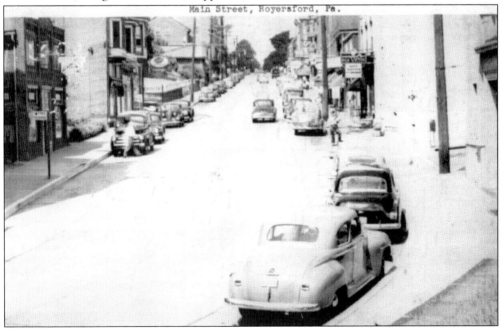

Main Street, Royersford, Pa.

Main Street, Royersford, Pa.

Beginning with World War I, there was a decline in postcard publishing. Local postcards seemed to make a return in the early 1950s, when these cards were distributed. The above view shows Main Street from Fourth Avenue, looking west. The Penn Theater is on the left, and Miller's Candy Store is on the right. In the photograph below, looking east on Main Street, the sign for Sutton's Drug Store is visible.

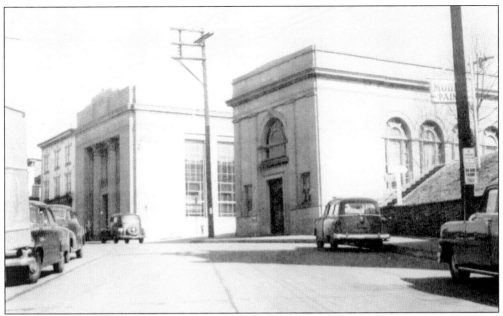

The first building on the right is the National Bank Building, and just above Third Avenue is the Royersford Borough Hall. The borough purchased this building to be used as the new hall in 1943.

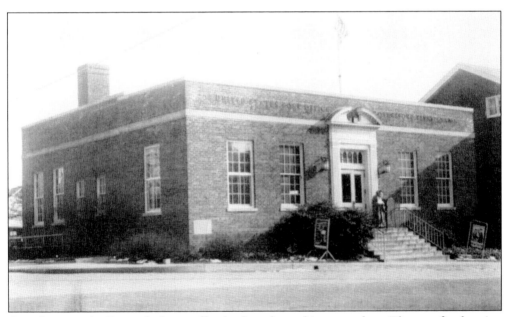

Over the years, the Royersford post office has been located in many places. The very first location was at Custer's Tavern in 1844. The brick building pictured in this postcard was opened in 1937 at Fifth Avenue and Main Street and served the community for many years.

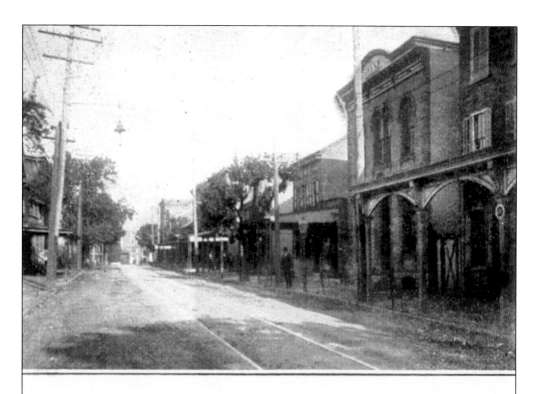

Main Street, Spring City, Pa., looking North.

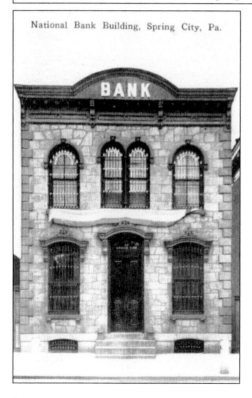

National Bank Building, Spring City, Pa.

These two 1905 views of Main Street in Spring City show the National Bank Building. In the above photograph, several stores and the trolley tracks can be seen. In the view to the left, the front of the National Bank of Spring City is shown. The bank first opened for business in 1872. The total cost of this building was $11,000, and the first president of the bank was Casper S. Francis. The building is still in existence today and is now a private residence.

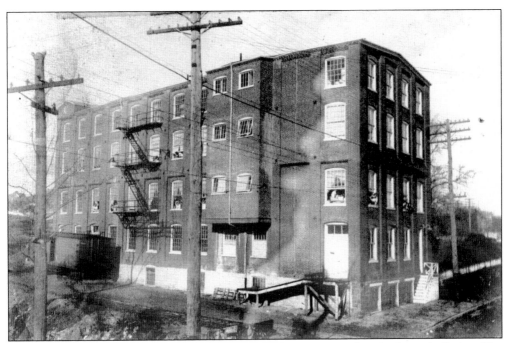

The Valley Forge Flag Factory was at the corner of Yost Avenue and Main Street in Spring City. While most of the other industries were located on South Main Street or Bridge Street, the flag factory was right in the middle of things on North Main Street. The company began operation *c.* 1932 in Spring City and later acquired the buildings pictured here. The above photograph shows the single building that stood in the spot before the flag company purchased the property. Although flag manufacturing has ceased in Spring City, the factory buildings have been given a new lease on life as the Flag House apartments for senior citizens.

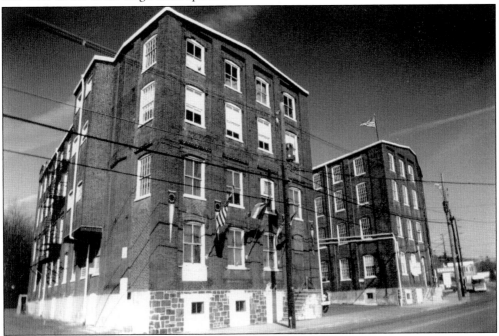

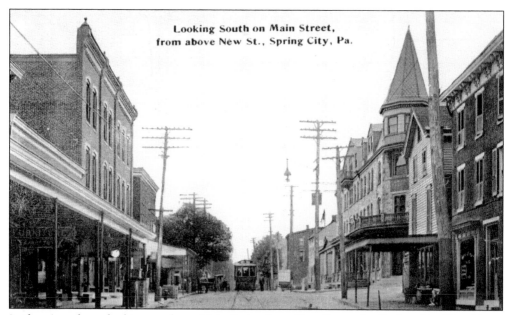

Looking South on Main Street,
from above New St., Spring City, Pa.

In the view above, looking south on Main Street from New Street, the Spring City Hotel is on the right. In the middle of the street farther south, the trolley passes by the hardware store on the left. In the view below, taken from above New Street, the hotel is on the left, and the barbershop is on the right.

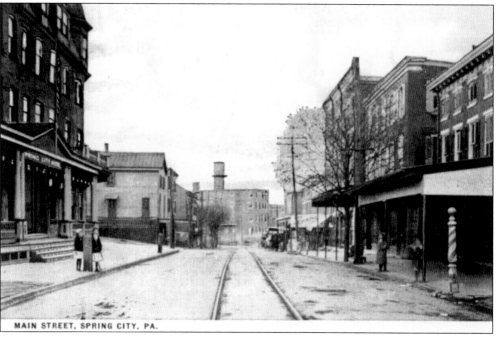

MAIN STREET, SPRING CITY, PA.

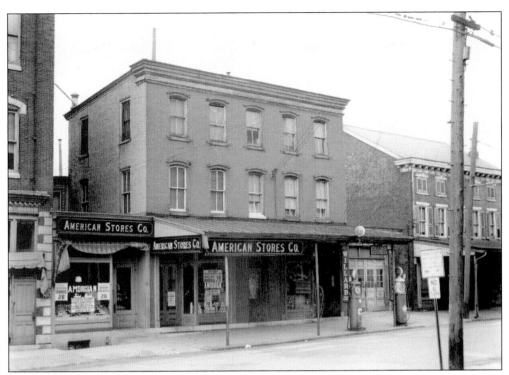

The S.R. Haines Electric Shop (at 93 North Main Street) is pictured *c.* 1930 with gas pumps out front. Next to it is American Stores, the local grocery store.

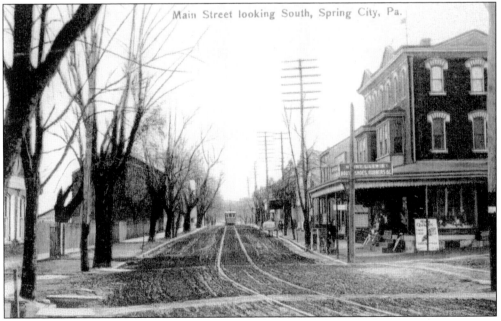

This 1910 view looks south on Main Street from Hall Street. Harry L. Lewis's store is at the right corner, and the Spring City Foundry is to the left. At that time, it was known as the Yeager and Hunter Stove Works. The trolley has just passed the old pattern house on the left. This brick pattern house, one of the original stove works buildings, remained there until 1991.

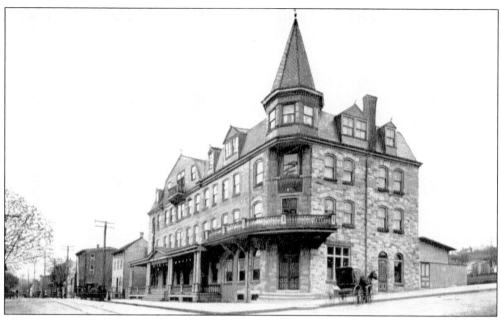

The Spring City Hotel is located downtown at the corner of Main and New Streets. The cornerstone for this hotel was laid in 1892. When it was completed, it was the showplace of the town. The hotel had gas and electric lights, flush toilets, and hot and cold running water in the bathrooms. In 1919, the hotel was decorated for the World War I victory parade, as shown in the photo postcard below. The hotel is still in operation today and features a dining room and cocktail lounge.

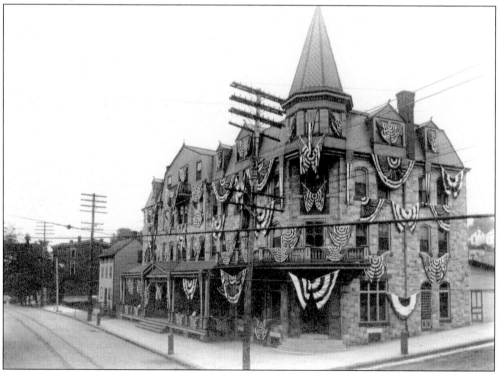

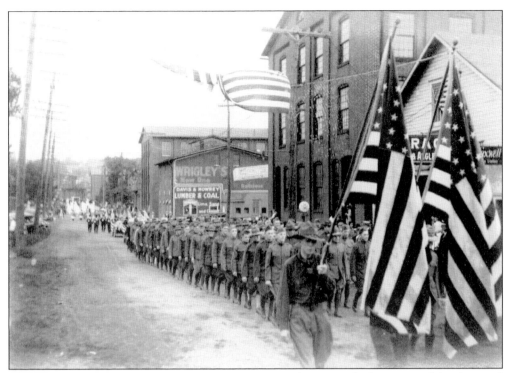

At the end of World War I, many small towns across the nation had victory celebrations and parades. Spring City and Royersford had a large parade, and a series of postcards with scenes of this memorable day was published. These two scenes are of the parade on Bridge Street near the Main Street intersection.

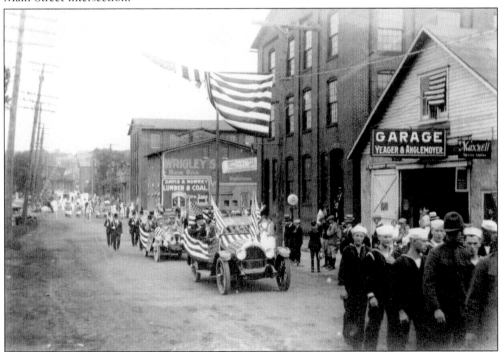

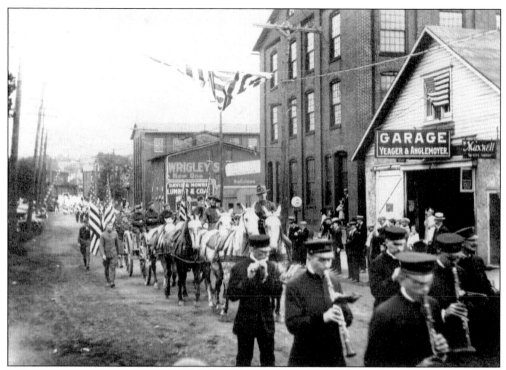

In this view of the parade, six white horses pull a wagon carrying some of the returning war veterans. It was a joyous day, as World War I, the "war to end all wars," had ended in victory.

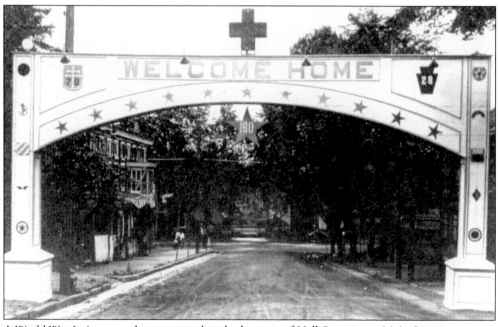

A World War I victory arch was erected at the bottom of Hall Street near Main Street.

Six

COMMUNITY

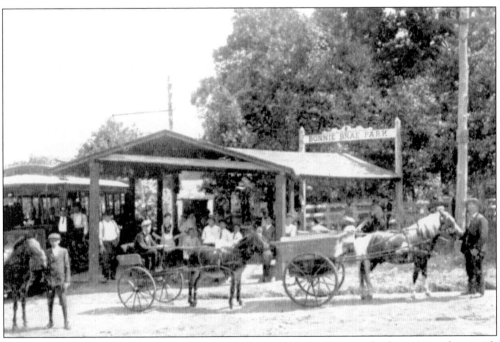

The communities of Spring City and Royersford continued to grow in the late 1800s, along with the development of industry. The fertile farmland from Chester and Montgomery Counties that paralleled the river was divided and subdivided so that homes could be built. Many of these fine early Victorian homes were captured on postcard images. The home of J.A. Buckwalter, in Royersford, and the Broad Street home of auditor general Dr. William P. Snyder, in Spring City, are just two examples. Amusement parks were built just outside of town. Lakeview Amusement Park was built in Royersford, and Bonnie Brae Park, just outside of Spring City, was built. Spring City also had a racetrack with a full schedule of horse races and shows. French Creek, which flows nearby, was a popular place for camping and swimming. Some of these early camps still exist today.

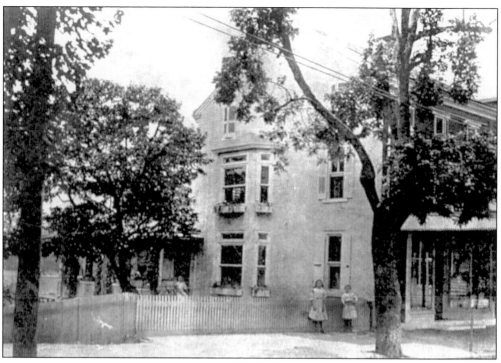

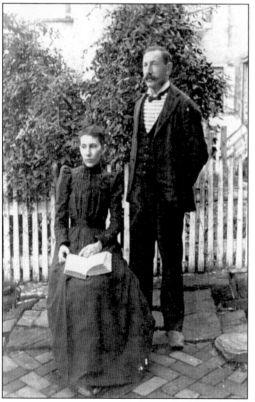

Frank Kline operated a jewelry store at 13 North Main Street in Spring City. It was a store that his father Reuben Kline had started in 1867. Frank Kline sold and repaired watches, did engraving, and had a complete eyeglasses department. At the back of his property was a building that housed incubators for the chickens that he raised. Beginning in 1903, Kline started to publish postcards and sell them at his jewelry store. One hundred years later, it is for these treasured postcards, many of them featured in this book, that Kline is best remembered. He and his wife are shown in this photo postcard from 1905.

H. G. Peterman's Residence,
Spring City, Pa.

This 1915 view shows the H.G. Peterman home, located next to the Spring City Hotel across the street from the hardware store. The house is still there, but the beautiful lawn is now a parking lot, and there is no porch for the rocking chairs.

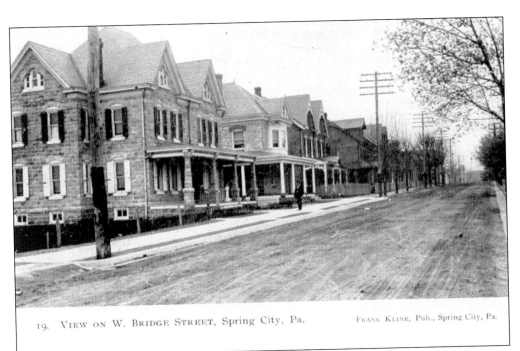

19. VIEW ON W. BRIDGE STREET, Spring City, Pa. FRANK KLINE, Pub., Spring City, Pa.

In this view looking west on Bridge Street in Spring City, the road is not paved, but it looks as if the sidewalks and curbing are new. This was one of Frank Kline's numbered series of postcards, and it dates from *c.* 1907.

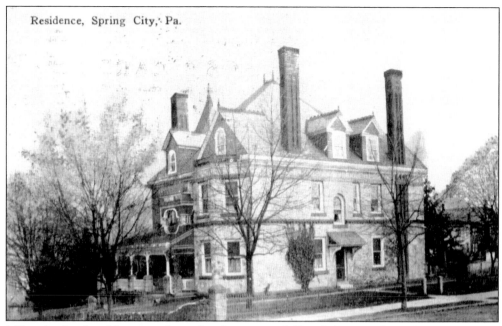

Residence, Spring City, Pa.

Milton Latshaw's residence was located at the corner of Church Street and Yost Avenue in Spring City. It was a splendid stone structure with three chimneys, an iron picket fence, a carriage house, and a stone wall that ran along Yost Avenue to Main Street. The house has been gone for years now, and it was just recently that the last sections of the old stone wall were removed.

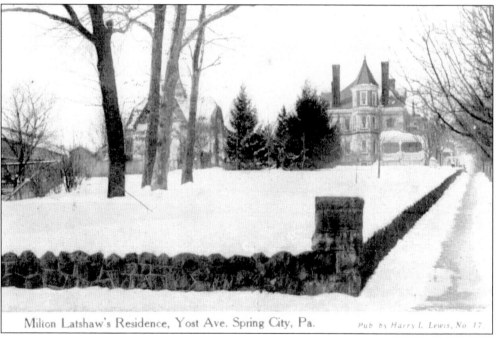

Milton Latshaw's Residence, Yost Ave. Spring City, Pa. Pub by Harry L. Lewis, No 17

94

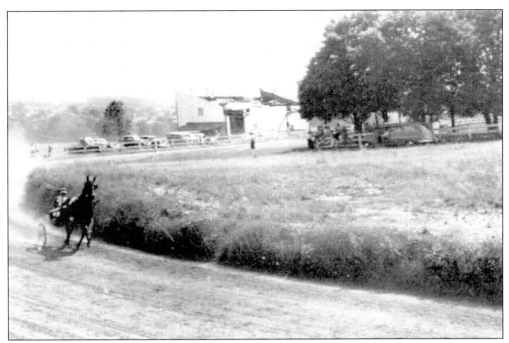

Horse racing began early on in Spring City. An overview map from 1893 shows a track sketched in on Wall Street. Sometime much later, it became organized, and the Spring City Driving Association was formed. There were grandstands and stables on the grounds. Racing and horse shows were held regularly in the 1930s and 1940s. This track was located on Wall Street, where the Spring City Elementary School now stands.

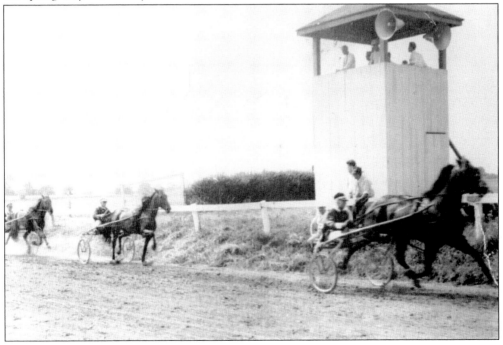

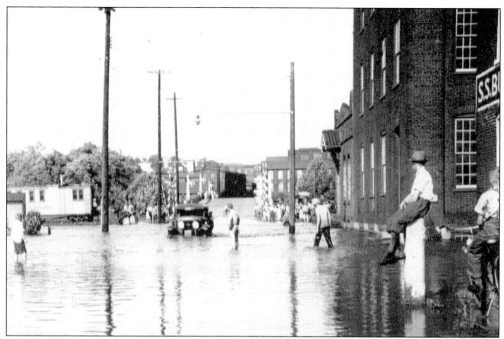

The sudden rising of the Schuylkill River over the years has given these communities their share of floods to deal with. Pictured here in 1942, in the vicinity of the Buckwalter Feed Company, are several of the townspeople out to view the happenings. It seems like a festive affair, as people are lined up to watch the waters advance. This entire section of Bridge Street in Spring City is located in the flood plain.

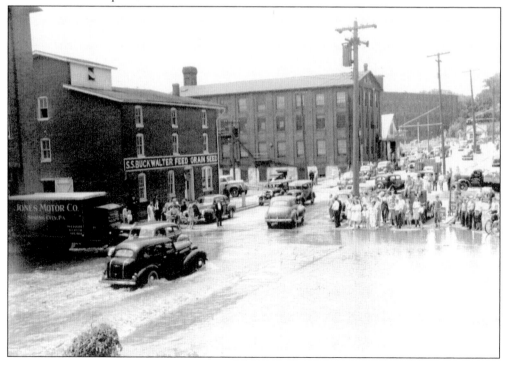

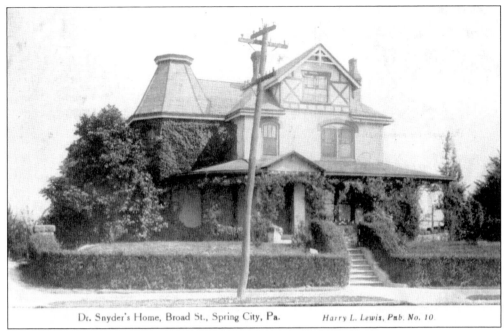

Dr. Snyder's Home, Broad St., Spring City, Pa. *Harry L. Lewis, Pub. No. 10*

Dr. William P. Snyder's home was located on Broad Street in Spring City. He served as the state auditor general. In the postcard view below, published by Kime's Stationery, the caption reads, "Residence of Auditor General Snyder."

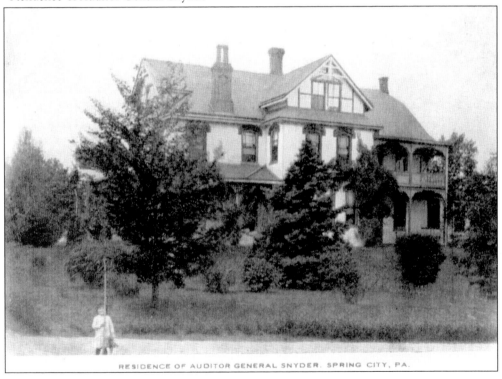

RESIDENCE OF AUDITOR GENERAL SNYDER, SPRING CITY, PA.

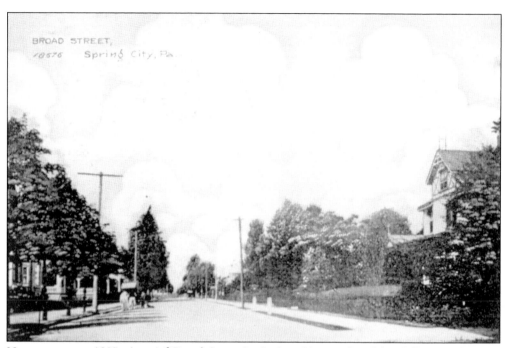

Here are two *c.* 1905 views of Broad Street in Spring City, produced by different publishers. Hitching posts, seen in both views, were quite common, and a few still remain.

Horace D. Heistand lived at 335 Chestnut Street in Spring City. On occasion, he privately published photo postcards of many local homes and farms. Depicted on this 1908 postcard, mailed by his wife to one of her friends, is a photograph of their house.

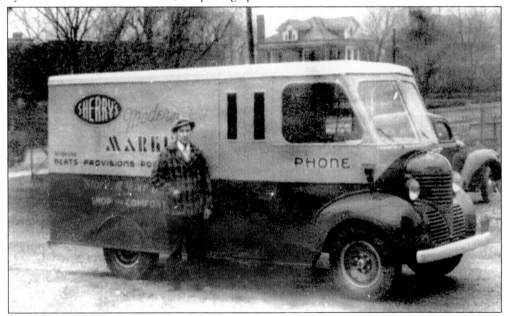

Sherwood H. Hallman of Spring City is probably best remembered for his heroic service in World War II and for the Congressional Medal of Honor, which was awarded to him posthumously in 1945. Before going into military service, Hallman had a small "store on wheels." He sold meat, fresh fruit, and groceries by delivering them to people's doors. In this *c.* 1940 view, he is posed in front of his Modern Market.

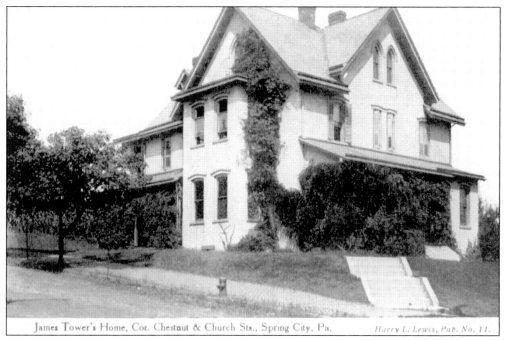

James Tower's Home, Cor. Chestnut & Church Sts., Spring City, Pa. *Harry L. Lewis, Pub. No. 11.*

The James Tower house, at Chestnut and Church Streets in Spring City, stood just across the street from the old Lutheran church.

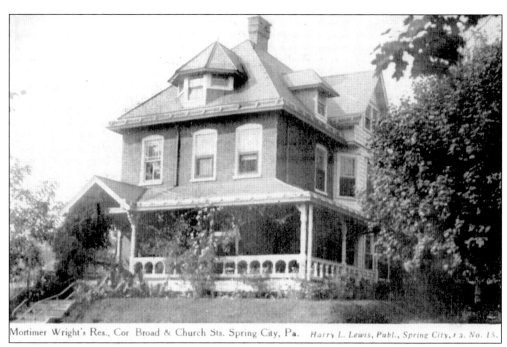

Mortimer Wright's Res., Cor Broad & Church Sts. Spring City, Pa. *Harry L. Lewis, Publ., Spring City, ı a. No. 15.*

Mortimer Wright's residence, on the corner of Church and Broad Streets, was located on the opposite corner from the Spring City Methodist Church.

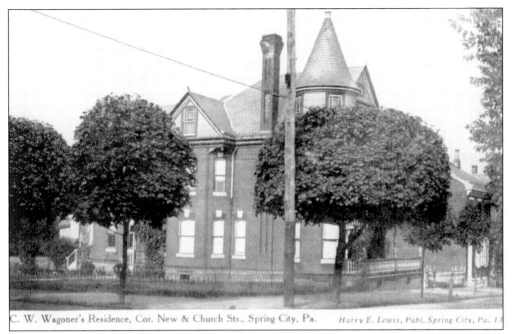

C.W. Wagoner's Residence, Cor. New & Church Sts., Spring City, Pa. *Harry E. Lewis, Publ. Spring City, Pa. 13*

C.W. Wagoner's residence, on the corner of New and Church Streets in Spring City, was a fine brick building with a wrought-iron picket fence. It remains with us today and, on the surface, looks the same.

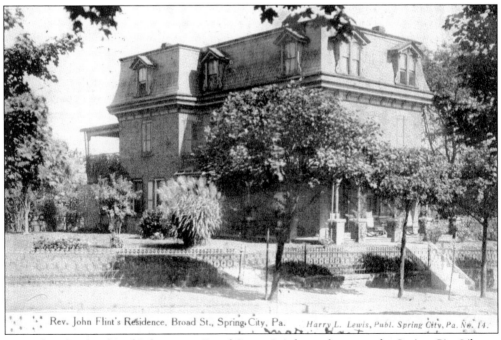

Rev. John Flint's Residence, Broad St., Spring City, Pa. *Harry L. Lewis, Publ. Spring City, Pa. No. 14.*

Rev. John Flint lived in this house on Broad Street. It is located next to the Spring City Library.

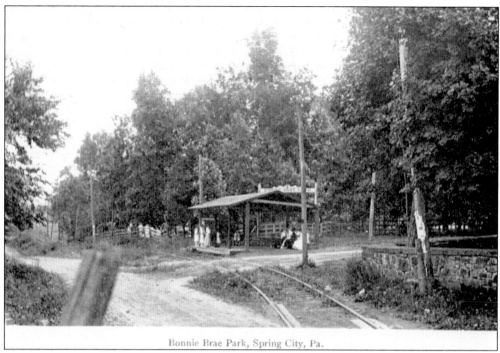

Bonnie Brae Park, Spring City, Pa.

Bonnie Brae Park, on the Schuylkill Road just outside of Spring City, had its beginnings when the local trolley company began operating in 1899. It had developed into a regular amusement park, complete with a carousel, by the early 1920s. Trolley service stopped in 1924, and the park was closed soon thereafter. The park was purchased in 1926 by the Ku Klux Klan, under the name of the Bonnie Brae Association. The group remained active for many years at this location. In 1950, the property was sold, and eventually an auction business grew up on the site. To this day, weekly auctions are still held at Bonnie Brae.

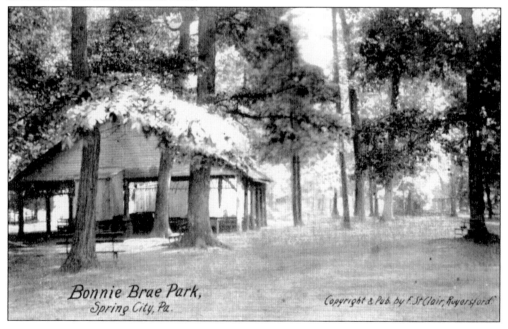

Bonnie Brae Park,
Spring City, Pa.

Copyright & Pub. by F. St Clair, Royersford

These *c.* 1920 postcard views were published by Kime's Stationery in Spring City. Both homes are located on Broad Street.

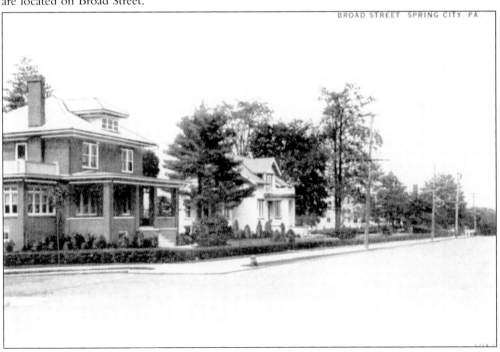

BROAD STREET, SPRING CITY, PA.

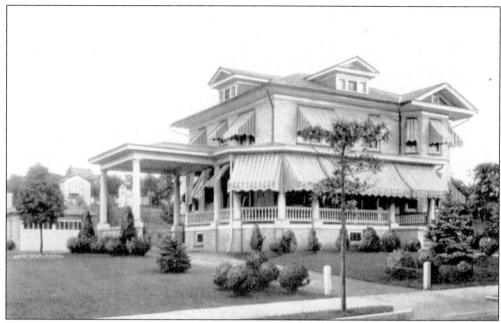

This home is located at Yost Avenue and Wall Street in Spring City.

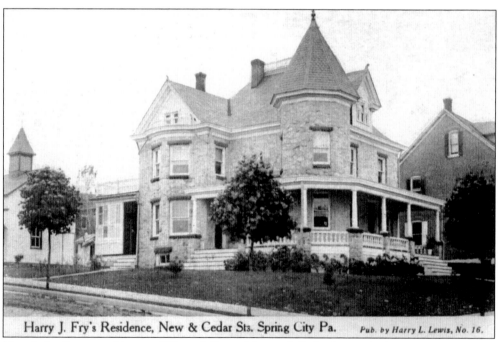

Harry J. Fry's Residence, New & Cedar Sts. Spring City Pa. Pub. by Harry L. Lewis, No. 16.

Here is the former residence of Harry J. Fry, at New and Cedar Streets in Spring City.

French Creek, a meandering little stream two miles west of Spring City, was always a popular place for people to go camping and fishing. Several church-run camps and retreats were located there. In the early 1900s, covered bridges were found on almost every road that crossed the stream. Rapp's Dam, a popular swimming and picnic area, is shown in the early-1900s view below. Although Rapp's Dam is probably closer to Phoenixville as the crow flies, this local postcard publisher seems to have claimed it for Spring City.

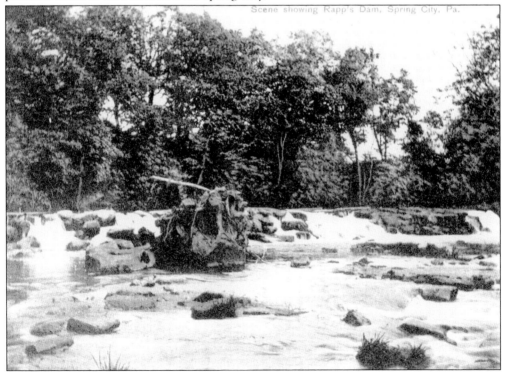

These are two views from Church Street. Above is the house at the corner of Yost Avenue and Church Street, and below is a view looking south on Church Street.

This *c.* 1910 view looks down Bridge Street Hill in Spring City.

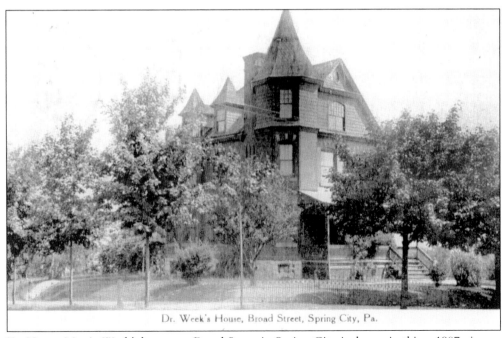

Dr. Week's House, Broad Street, Spring City, Pa.

Dr. Henry Martin Week's house, on Broad Street in Spring City, is shown in this *c.* 1907 view.

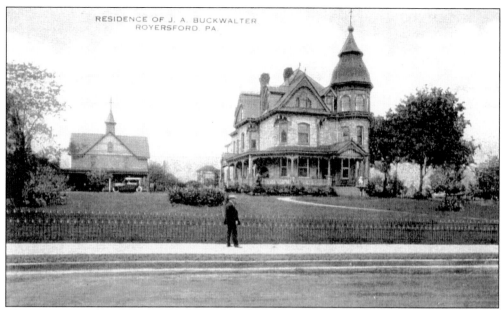

These are two views are of the residence of J.A. Buckwalter. Buckwalter was president of the Buckwalter Stove Company, in Royersford. His home was located on Fourth Avenue and Walnut Street where the Golden Age Manor is today.

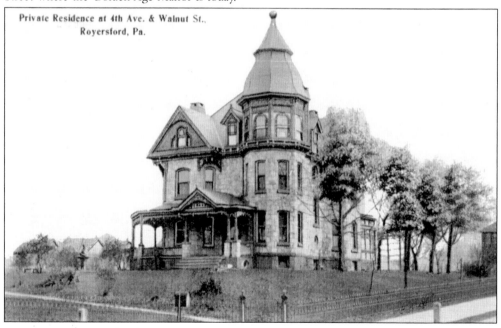

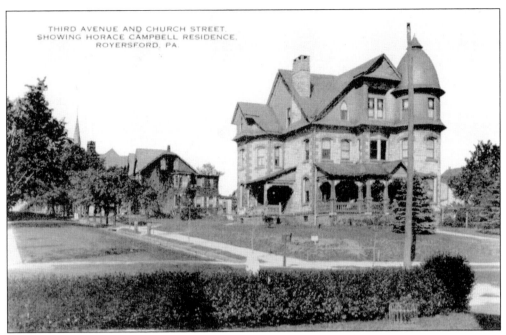

Horace Campbell's residence was located at Third Avenue and Church Street in Royersford.

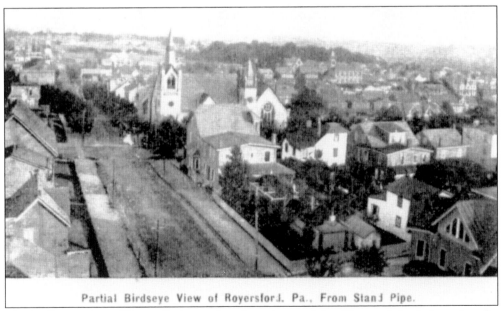

Partial Birdseye View of Royersford, Pa., From Stand Pipe.

This bird's-eye view of Royersford was taken from the standpipe. The standpipe belonged to the water company and was located at Fourth Avenue and Chestnut Street.

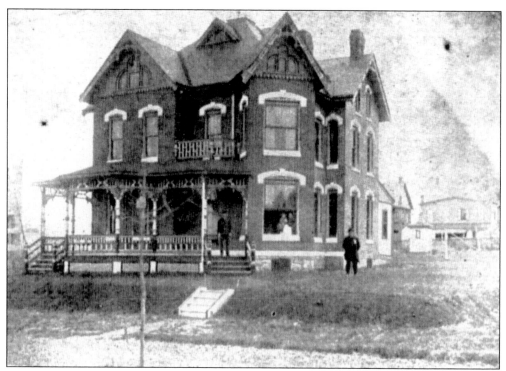

Taken on Main Street in Royersford between Fifth and Sixth Avenues, this 1906 photograph shows the former home of Willis Lewin.

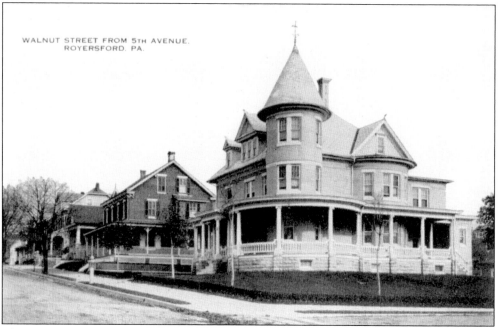

This *c.* 1910 Royersford photograph was taken on Walnut Street from Fifth Avenue.

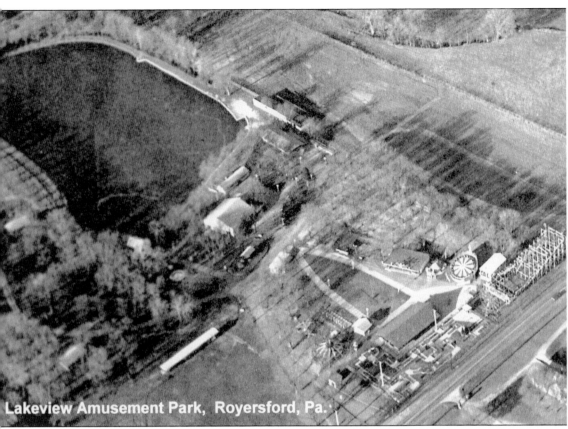

Lakeview Amusement Park, Royersford, Pa.

The property on Township Line Road, later to be known as Lakeview Amusement Park, was acquired *c.* 1900 by Benjamin P. Kern. In the winter, Kern cut blocks of ice from the lake and stored them in an icehouse, to be sold to local customers in the warmer months. In the summer, the lake was used for swimming and family picnics. Kern saw the potential for developing this picnic grove into a larger amusement park. In 1919, he purchased a 20-passenger motorboat to give rides on the lake. The park grew, and soon groups from surrounding areas were booking the site for picnics and special events. The park became home to the annual Montgomery County Farmer's Picnic. Some of the park rides included a train ride, a "whip," bumper cars, and a grand old carousel with magnificently carved wooden horses. Lakeview continued to operate through the 1970s, long after many other small parks had closed their doors. In the end, however, it shared the fate of many other parks and ended up being a shopping center.

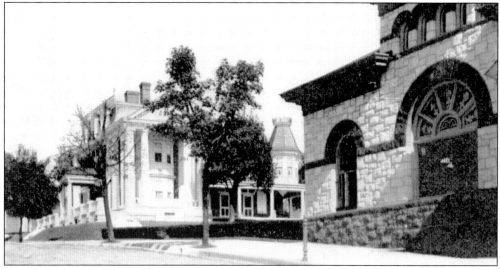

In these 1905 postcard views, the residence and office of S.B. Latshaw are seen on Fourth Avenue, just above Main Street in Royersford. In the photograph below, the Baptist church and the standpipe also are shown.

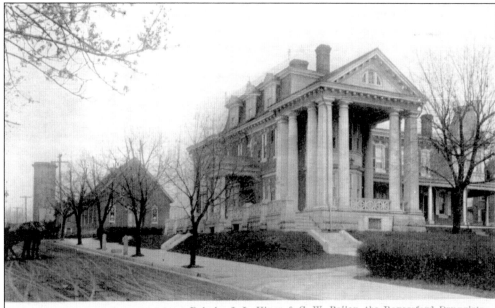

Pub. by J. L. Hixon & G. W. Bailey, the Royersford Druggists
FOURTH AVENUE, SHOWING BAPTIST CHURCH, ROYERSFORD, PA.

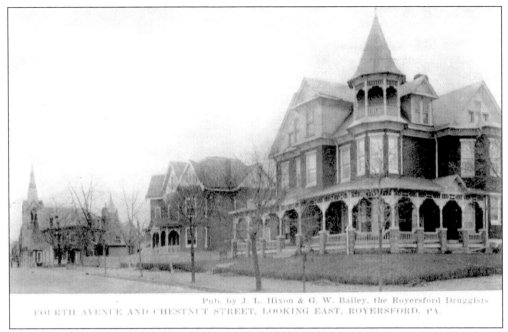

Pub. by J. L. Hixon & G. W. Bailey, the Royersford Druggists
FOURTH AVENUE AND CHESTNUT STREET, LOOKING EAST, ROYERSFORD, PA.

Looking east, this *c.* 1909 Royersford view was taken on Fourth Avenue. The house on the right is the former residence of W.L. Latshaw.

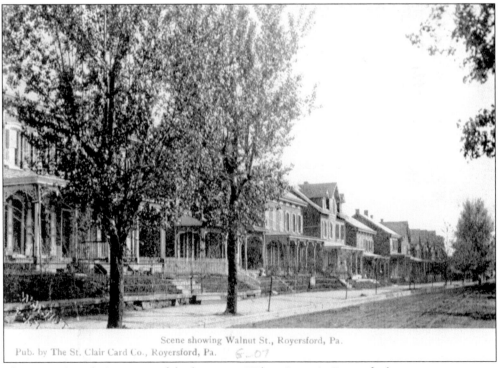

Scene showing Walnut St., Royersford, Pa.
Pub. by The St. Clair Card Co., Royersford, Pa. 6-07

This 1905 view depicts some of the homes on Walnut Street in Royersford.

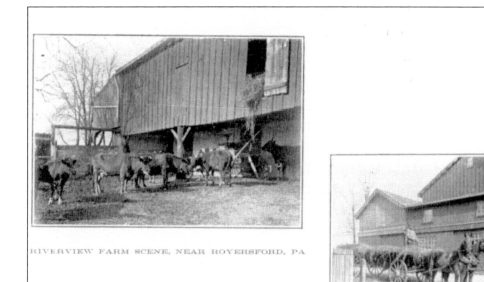

River View Farm, one of the many farms in the surrounding area near Royersford, is seen here in 1906.

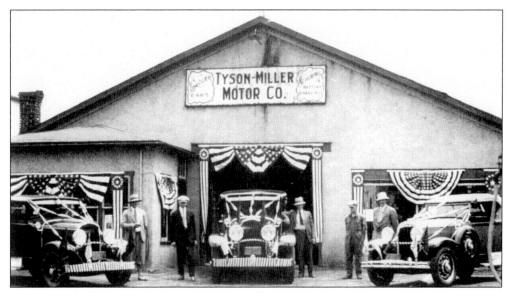

The Tyson Miller Motor Company was a well-known local automobile dealer that served both communities.

This is a scene on Church Street in Royersford, looking north.

Here is a 1907 view of Walnut Street between Third and Fourth Avenues.

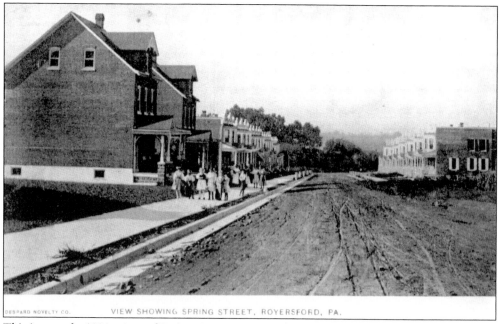

VIEW SHOWING SPRING STREET, ROYERSFORD, PA.

This is an early-1900s view of Spring Street in Royersford.

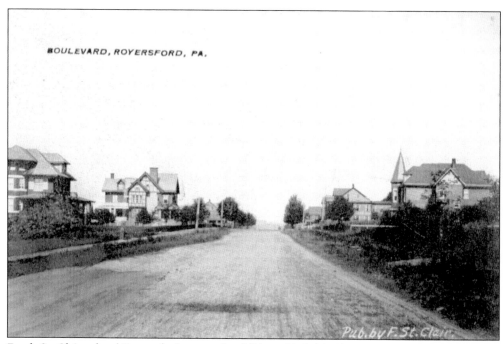

BOULEVARD, ROYERSFORD, PA.

Frank St. Clair, a local Royersford postcard publisher, titled this 1908 view "Boulevard." He was, of course, referring to Church Street in Royersford.

Seven

CHURCHES

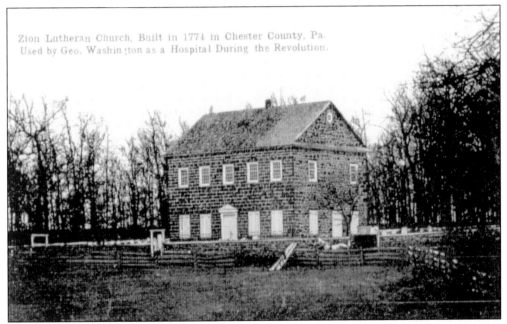

Zion Lutheran Church, Built in 1774 in Chester County, Pa.
Used by Geo. Washington as a Hospital During the Revolution.

The two towns have a rich religious history that predates the golden age of postcards by over 50 years. The Methodist church in Spring City traces its beginnings to the first sermon delivered by a Reverend Cox at the Lyceum in 1845. In fact, by 1899 the Methodist church had published a book, *A Brief History of the Methodist Church in Spring City.* The Royersford Methodist Episcopal Church was set apart as a separate body in 1887. Of the many churches on both sides of the river, the one with the richest history is the Zion Lutheran church. The original Zion Lutheran church, built in 1774 and pictured above, served as a hospital for George Washington's troops during the Revolutionary War.

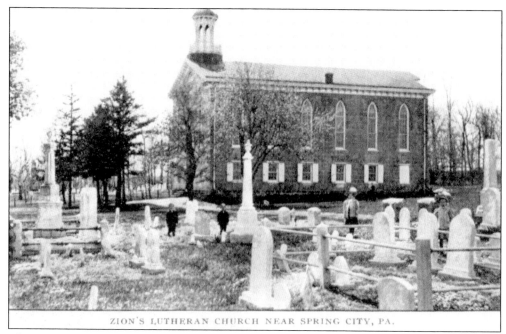

ZION'S LUTHERAN CHURCH NEAR SPRING CITY, PA.

The Zion Lutheran church, on Route 724 near Spring City, dates back to the period of the American Revolution. The original church was located near the present-day structure and used by George Washington's troops as a hospital. The Lutheran congregation that formerly met at a church located in the borough now gathers here as well.

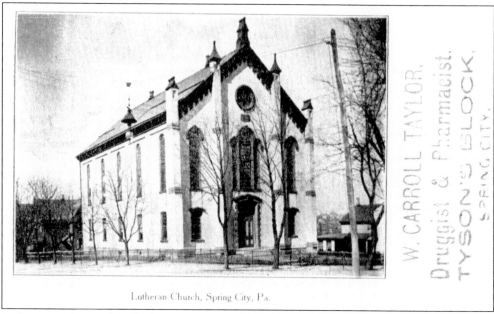

Lutheran Church, Spring City, Pa.

Lutheran services within the borough of Spring City were held as early as the 1860s, but it was not until 1872 that church members became organized. In 1879, the cornerstone for the Lutheran Church of Spring City was laid at the corner of Chestnut and Church Streets. The building remains, but the congregation has combined with the Zion Lutheran church and now meets in the building on Route 724 near Spring City.

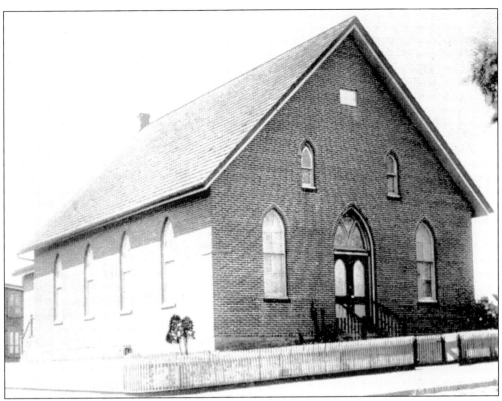

Built in 1879, the First Baptist Church is one of the oldest churches in Royersford.

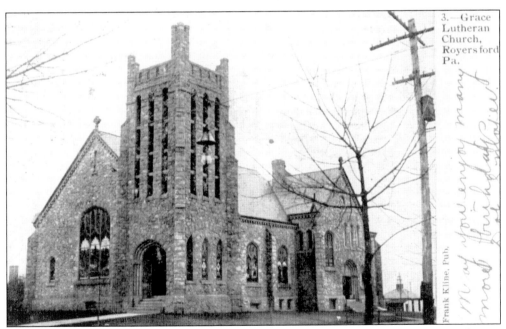

3.—Grace Lutheran Church, Royersford Pa.

Frank Kline, Pub.

The Grace Lutheran Church of Royersford was built on the corner of Sixth Avenue and Main Street in 1892. The corner lot on which the church is located was donated by Rebecca Lewin.

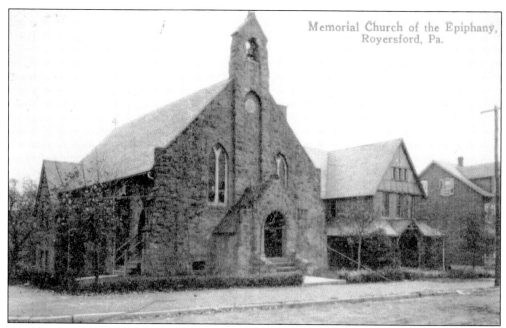

The Memorial Church of the Epiphany in Royersford was located at the corner of Third Avenue and Washington Street. The photo postcard below, from the early 1900s, gives an interior view of the church.

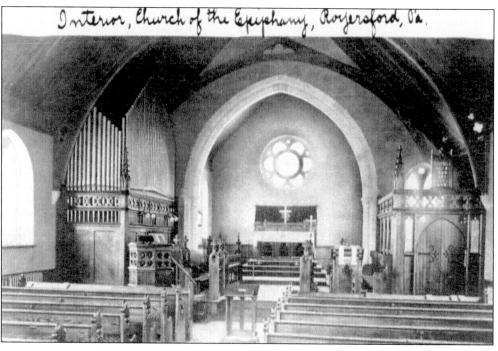

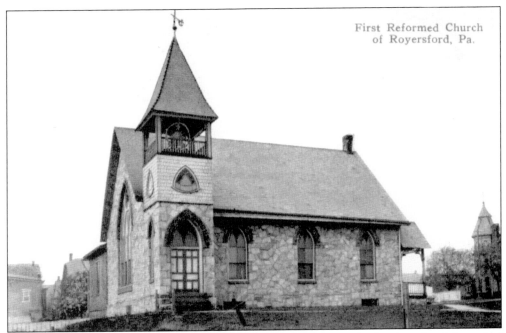

First Reformed Church
of Royersford, Pa.

The First Reformed Church of Royersford was dedicated in 1893. The Sunday school classes had begun in Royersford as early as 1890.

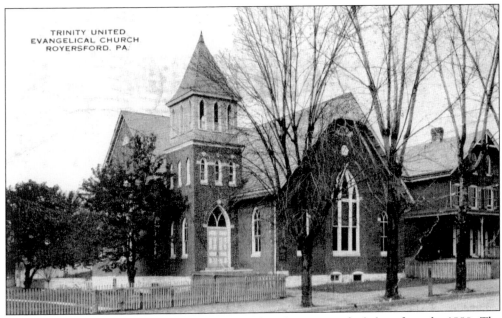

TRINITY UNITED
EVANGELICAL CHURCH
ROYERSFORD, PA.

The Trinity United Evangelical Congregational Church, in Royersford, dates from the 1890s. The construction of the church was begun in 1893.

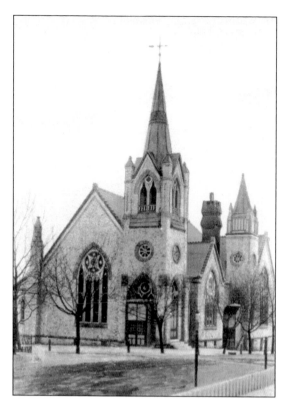

The Methodist Episcopal congregation in Royersford separated from Spring City in 1887. Construction of the new church began in 1891, and the building was dedicated in 1892. It is estimated that the total cost for the lot, building, and furnishings was about $35,000.

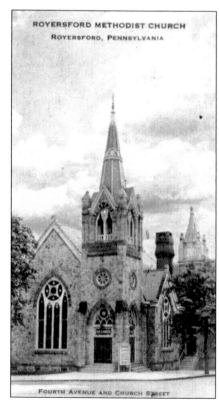

ROYERSFORD METHODIST CHURCH
ROYERSFORD, PENNSYLVANIA

FOURTH AVENUE AND CHURCH STREET

This United Methodist Church stands at the corner of Fourth Avenue and Church Street in Royersford.

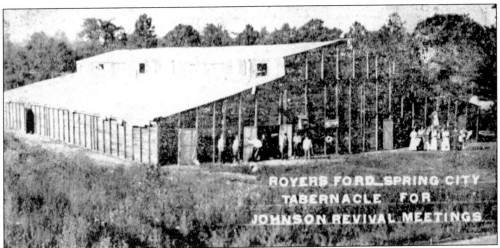

The lowlands on Bridge Street, near the present-day location of Ken Reed's Auction House, were the home of the Johnson Revival Meetings. In the postcard above, the building is referred to as the Royersford-Spring City Tabernacle. This view dates from 1910. In later years, there were ball fields located in this area.

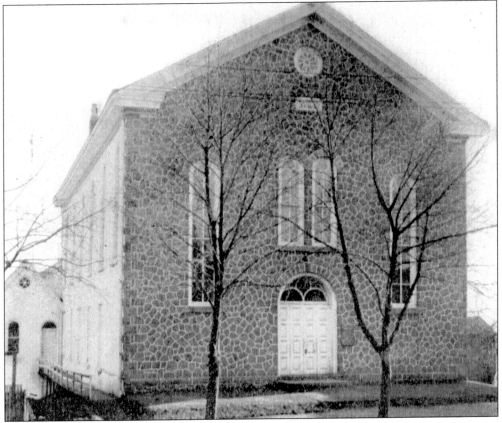

This original Methodist Episcopal building was located on Church Street in Spring City. It was completed in 1848 and was known as the Union Meeting House. In 1872, the church shown here was erected, and the original structure was dismantled.

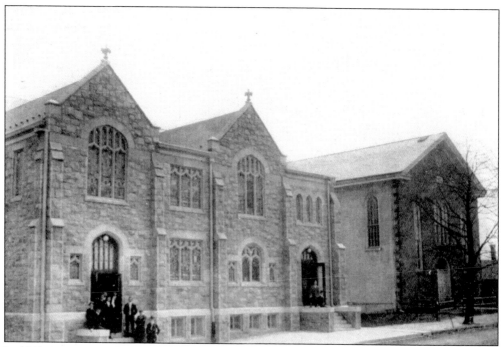

In 1909, a new section was added to the Spring City Methodist Church, shown in the above view on the left of the old church. In 1922 and 1923, the main church and tower were completed, as shown in the view below.

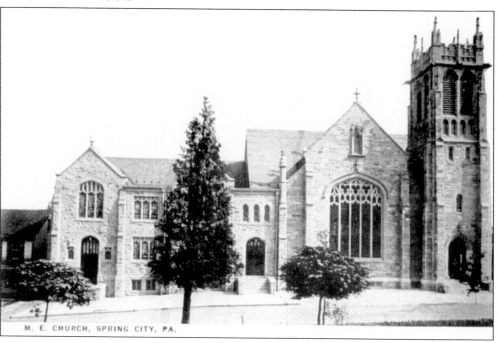

M. E. CHURCH, SPRING CITY, PA.

The Spring City Reformed Church is located on Chestnut Street. Its beginnings in Spring City go back to 1881, when Sunday school classes were being held at Mechanics Hall. The actual building was begun in 1884, and the congregation held its first service there on Christmas Day of that year. Construction of the church was completed in 1885.

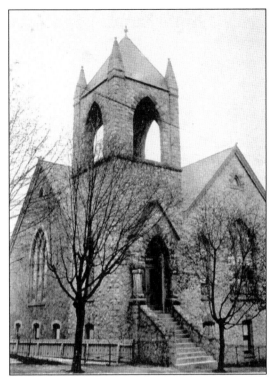

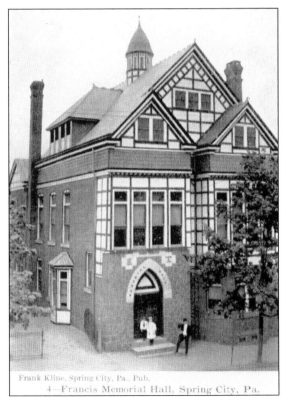

Frank Kline, Spring City, Pa., Pub.
4—Francis Memorial Hall, Spring City, Pa.

Francis Memorial Hall, located on Chestnut Street alongside the Reformed church, was a gift from Henry Francis and was built in 1894. The Reformed church today is better known as the First United Church of Christ.

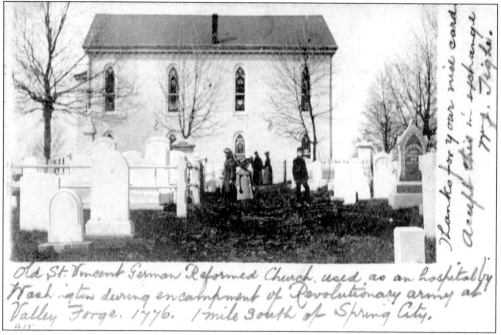

The old German Reformed church is located on Hill Church Road near Spring City. The congregation was formed in 1733, and today it is known as the East Vincent United Church of Christ.

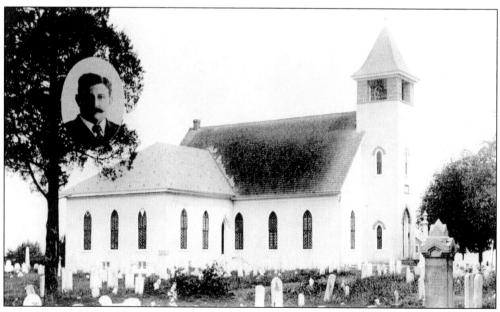

Located on Ridge Road a few miles above Spring City is another Reformed church with an early history. The Brownback Church, shown in this 1905 photo postcard view, traces its beginnings to 1743.